BALDOCK
THROUGH TIME
Hugh Madgin

AMBERLEY PUBLISHING

Acknowledgements

The compilation of a collection of photographs such as this is very much a co-operative venture. The enthusiastic assistance of Mrs Patricia Aspinall, Rhian Dodds, Terry Knight and Penny Oliver in locating photographs for reproduction has been crucial to the appearance of this book.

Baldock Library, Hertfordshire Archives & Local Studies and Hitchin Museum have also been of great assistance.

Special thanks are due to the family of the late R. F. Page for permission to use a number of Mr Page's fine photographs of Baldock.

First published 2013

Amberley Publishing
The Hill, Stroud
Gloucestershire, GL5 4EP

www.amberley-books.com

Copyright © Hugh Madgin, 2013

The right of Hugh Madgin to be identified as the Author of this work has been asserted in accordance with the Copyrights, Designs and Patents Act 1988.

ISBN 978 1 84868 117 0

British Library Cataloguing in Publication Data.
A catalogue record for this book is available from the British Library.

Typeset in 9.5pt on 12pt Celeste.
Typesetting by Amberley Publishing.
Printed in the UK.

Introduction

Baldock is a most singular town. Created by a gift of land by the Earl of Pembroke to the Knights Templar in the twelfth century, the town basically comprised a cross of two streets laid at right angles near the intersection of a minor Roman road with the ancient Icknield Way.

Even after its boundaries underwent expansion in 1882, Baldock was still less than 600 acres in size and was one of the smallest urban districts in the country until absorption into the large North Hertfordshire District Council in 1974.

The Knights Templar's town was well set out from the start; it had a charter for a market from 1199 and the two great streets at right angles were ideal for holding large markets and fairs.

After a congenial medieval period, Baldock appears to have declined somewhat, before reviving in the turnpike era, when the road from Stevenage through the town to Biggleswade and the north took on an importance it had never had before.

By the nineteenth century Baldock was a noted malthouse and brewery, and was well-placed to take advantage of the growth in beerhouses that occurred after 1830. It retained a large brewery – Simpson's – until 1965, and the last maltings carried on after this.

The establishment of the world's first garden city based on a hitherto insignificant hamlet nearby at the start of the twentieth century could have left Letchworth's older neighbour to rest on its laurels or merely become an adjunct to the new construct, but the twentieth century saw Baldock develop very much in its own way.

While numerous factories were being established in Letchworth, Baldock became the location for the world's largest hosiery factory, a development that bought a huge influx of new residents into the town.

At the same time, the Great North Road became the country's premier highway at the start of the 1920s, bringing a great deal of through trade to the town, which led to the proliferation of cafés and tea rooms during the interwar years.

After the Second World War, government scientists working at the secret Services Electronics Research Laboratory (SERL) plant alongside the Kayser Bondor factory made important strides in laser technology – in a story which is still probably better known to the KGB than the British public at large, but at some point no doubt will be dusted off and shown the light of day.

Today, Baldock benefits greatly from its electric train service to King's Cross and is a sought-after commuter town. Its main streets are packed with fine Georgian and earlier buildings; like the town in a wider sense, they more than amply repay detailed inspection.

<div align="right">Hugh Madgin, Stevenage</div>

St Mary's Church Tower
The church tower of St Mary's, showing the clock which was added in 1882. In recent years, this clock has made the headlines after North Hertfordshire District Council received a complaint regarding the noise of its chimes. In past times, Matins bells would be rung at 4 a.m., and during the winter (from Norton Fair on 30 October until 11 March) a curfew bell would be rung at 8 p.m.

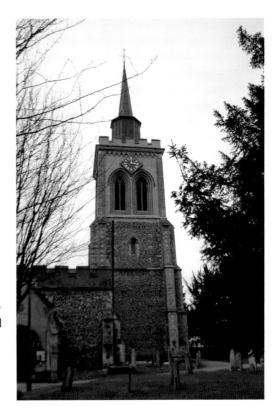

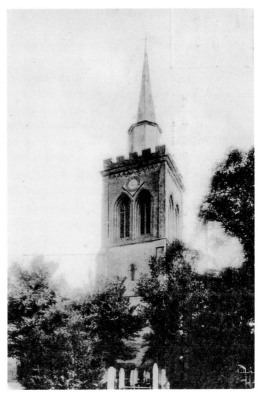

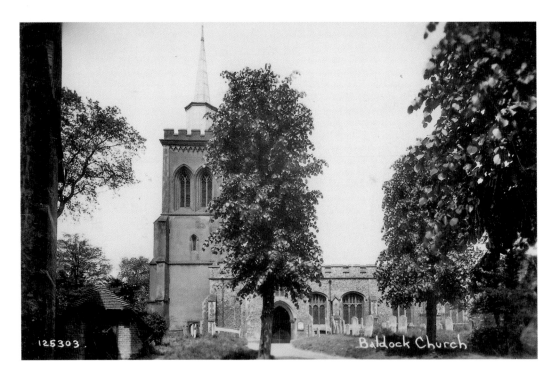

St Mary's Church

St Mary's church, seen from the south side. Samuel Pepys (whose diaries were edited by Baldock rector John Smith) commented that this was a 'very handsome church'. Major refurbishment of the church and its tower was completed in 2012.

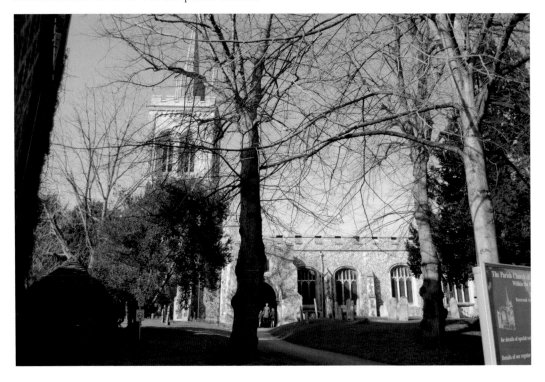

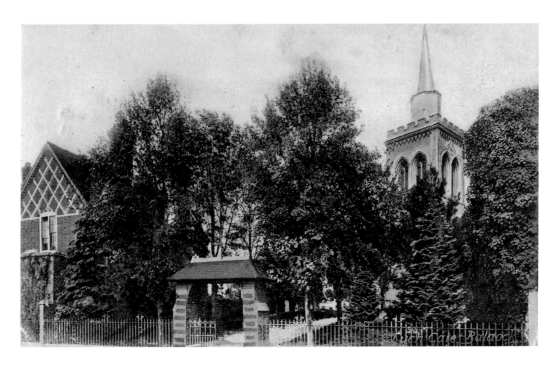

Lych Gate

Until 1870 the outbuildings of the George & Dragon stretched further down Hitchin Street to the site of Butterfield House. Indeed, it was their removal that enabled the old rectory to be replaced by Butterfield House. At the same time, this entrance onto Hitchin Street was opened up. The wrought iron gates in place today were presented to the church by the staff and pupils of The Grove School, Whitehorse Street, in 1951.

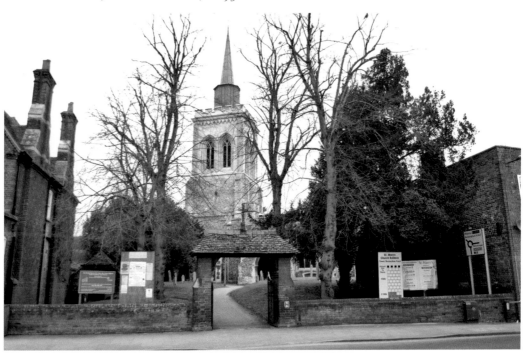

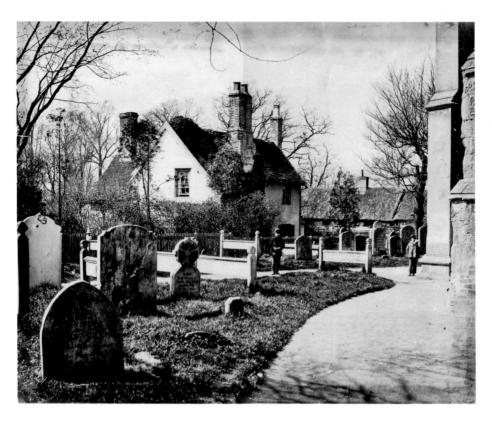

The Old Rectory

The old rectory was demolished in 1870. While the buttresses of the church tower have been renewed in the intervening 140 years and 3 yew trees have grown on the site of the old house, some of the gravestones are clearly identifiable in both photographs.

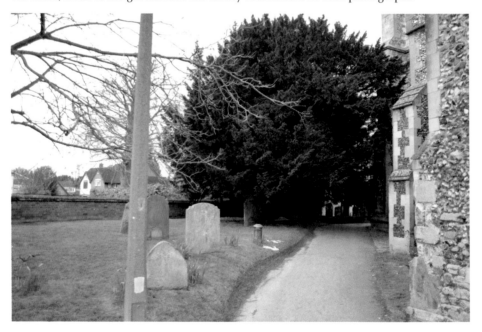

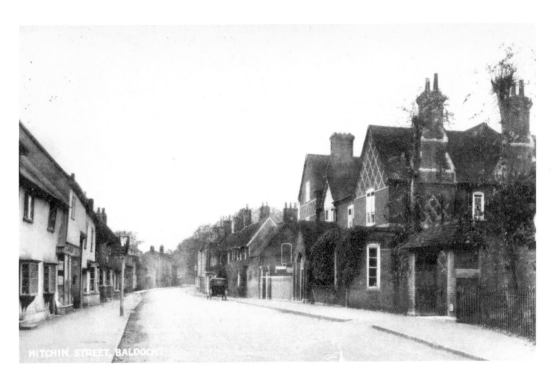

Butterfield House

The rectory of 1870 fronting Hitchin Street was the work of the leading Gothic Revival architect William Butterfield. An excellent example of Butterfield's enthusiasm for polychrome brickwork, the building ceased to be the rectory in 1960 and is now called Butterfield House.

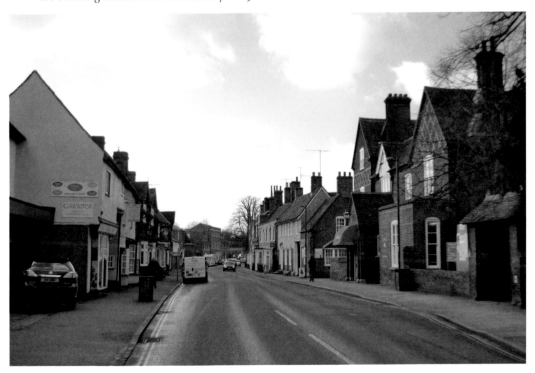

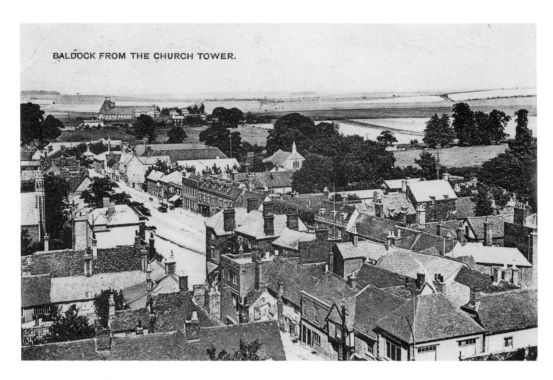

BALDOCK FROM THE CHURCH TOWER.

From the Church Tower I

The view eastwards from the church tower, showing Sun Street (foreground) and Whitehorse Street. On the fringe of the town, Page's Royston Road maltings can be seen. The largest of the town's maltings and the last to cease operation, these buildings were demolished in 1995 after sustaining fire damage. This card was published by H. Reed, whose premises were at No. 18 Whitehorse Street.

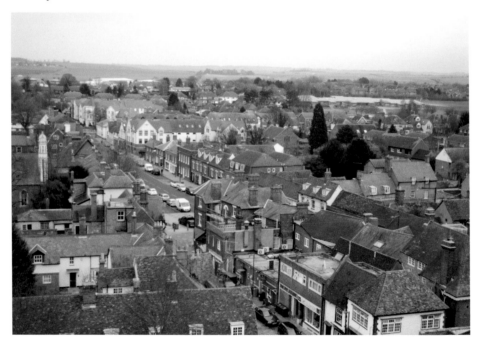

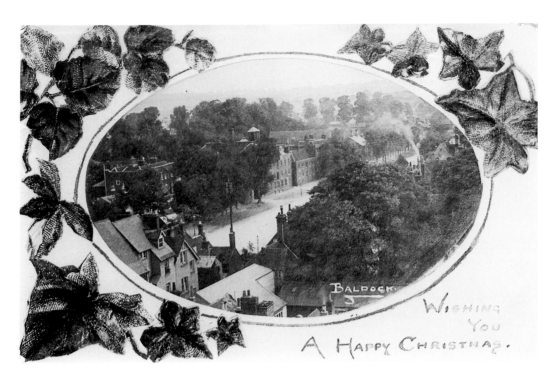

From the Church Tower II
With very little sign of activity, save for some smoke drifting languidly from a chimney, this view of the High Street shows the clearly-lit coloured roof of the building in the foreground, which would house the County Library until 1989.

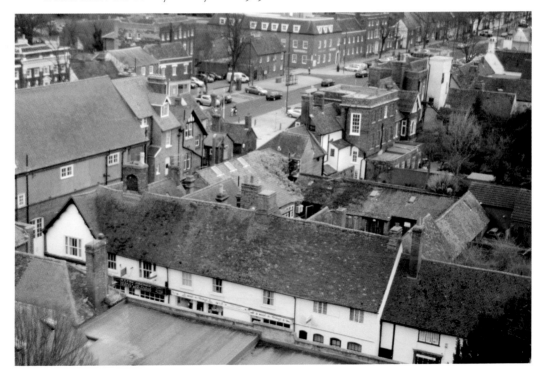

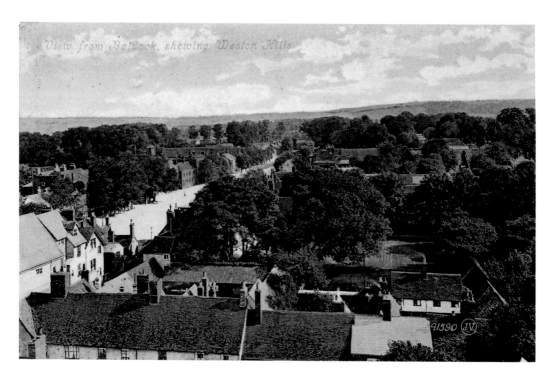

From the Church Tower III

Looking south towards Elmwood Park, on the west side of the High Street. Today this is the site of the Tesco superstore and industrial estate, but the earlier view can be identified by its tree-rich parkland.

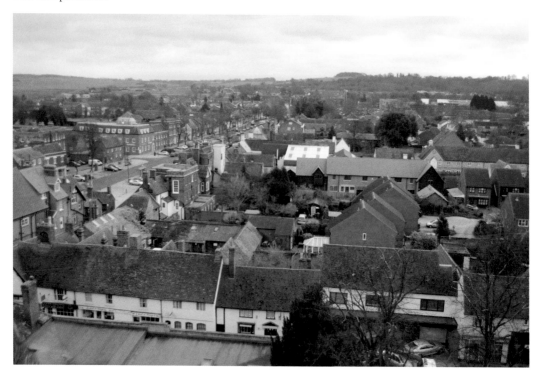

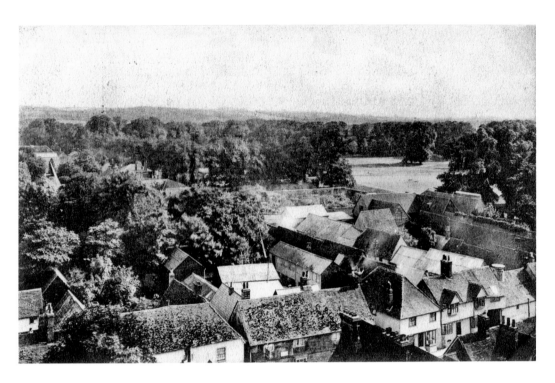

From the Church Tower IV

A final view from the church tower shows further evidence of the malting industry in Baldock. On the left of the old photograph, a cowl of the Seven Roes malting in Park Street can be seen among the trees, while to the right Page's Hitchin Street malting is visible.

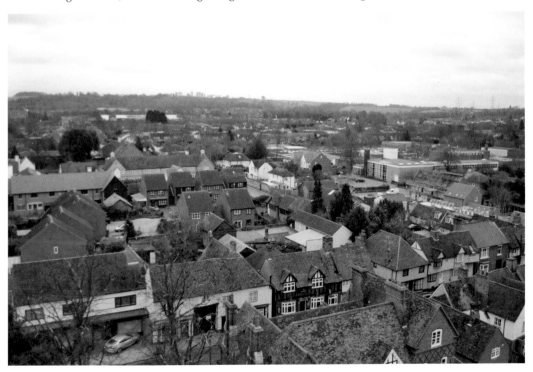

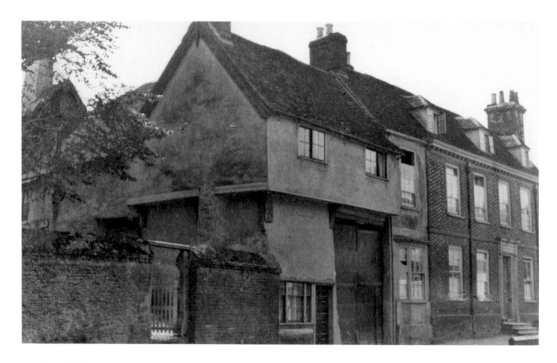

St Mary's Gatehouse

At the northern corner of the churchyard stands one of Baldock's finest timber-framed buildings. Dating from the fifteenth century, No. 3a Church Street retains two trefoiled lights on its south wall and has a crown post roof. Number 3 Church Street, St Mary's, shows the burnt headers of its brick frontage in the earlier picture, which were covered by rendering during the twentieth century.

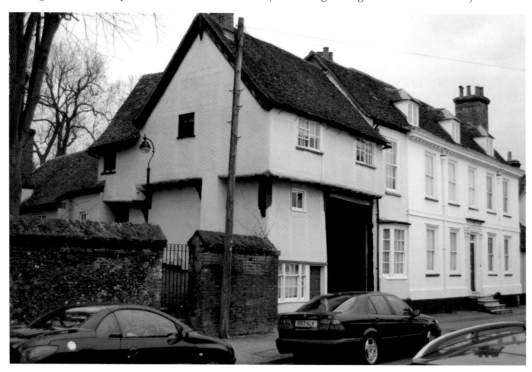

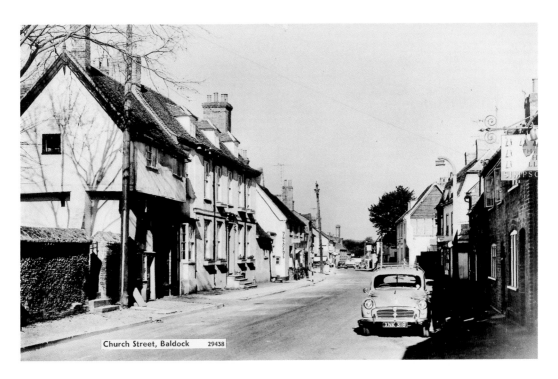

Church Street, Baldock 29438

Church Street

Looking north along Church Street. In the early 1960s there were four pubs remaining in the road: the Stag at the north end and the Eight Bells closed not long after the earlier view was taken, while the Star closed in 1980, leaving the Old Bulls Head, which closed by the end of the decade.

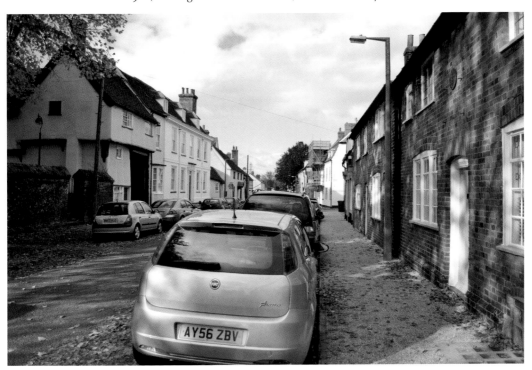

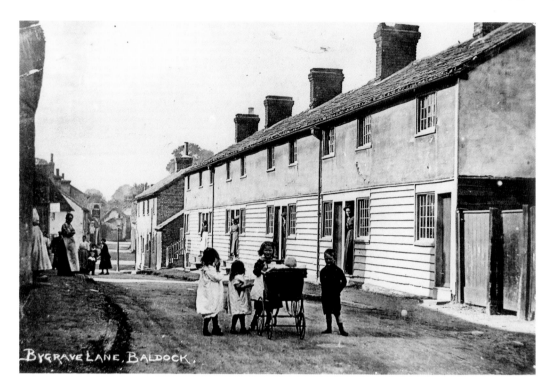

Bygrave Lane

Of the two terraces of ten houses that have existed in Baldock, one, Prospect Terrace in Clothall Road, (mostly) survives. The other, which became Nos 46–64 Icknield Way once Bygrave Lane had been renamed, was replaced by the industrial premises Icknield House. The future of this latter building now looks uncertain; its roof has been removed for some years. On the left-hand side of the street, the inn signs of the Stag's Head and the Black Eagle can just be made out in the earlier photograph, showing light and dark respectively.

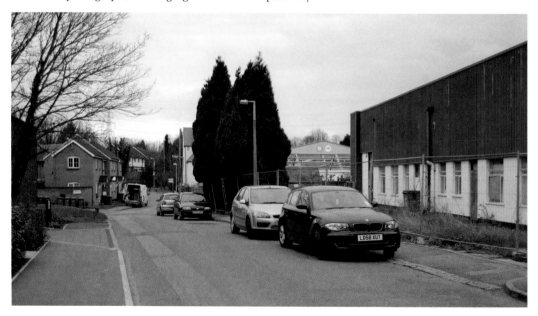

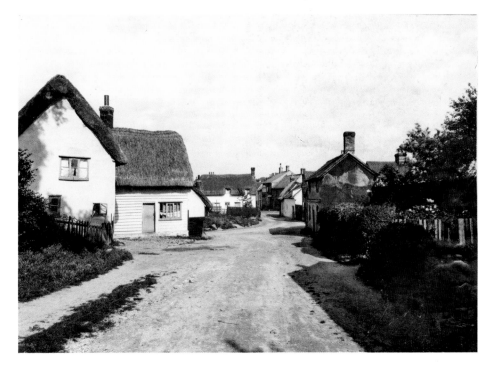

Norton End Looking East

The area of Norton End was characterised by a large number of small houses, which as the twentieth century progressed were demolished and replaced with better-appointed dwellings nearby and around the town. Today, the only building in this part of Baldock dating from before 1900 is the Orange Tree pub in Norton Road, a few yards to the right of this scene. The photographer of the original view was standing on a part of Icknield Way, which has vanished beneath the flats of Lavender Court, making an exact recreation of the earlier photograph impossible.

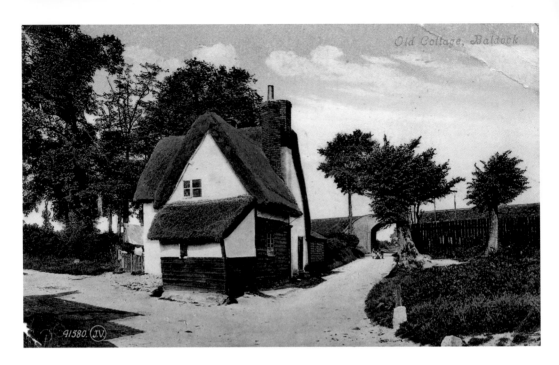

Cottages, Norton End

This pair of cottages achieved a measure of lasting fame for their appearance on postcards in the early twentieth century. The nearest, comprising two small rooms, one hearth and a cupboard-sized lean-to, was the home of William Millard and his wife Emma. Its Provisional Valuation in 1914 for Duties on Land Values under the Finance Act of 1910 was just £40 (£38 for the building and £2 for the few square feet it took up). The other cottage, home to platelayer George Gentle and family, and with some garden ground, was valued at £46 (£14 for the land only). Both cottages are seen from the south in the view on the previous page.

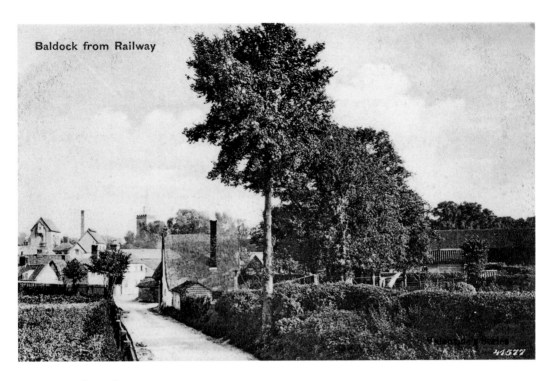

Baldock from Railway

From the Railway

Mr Gentle's house is seen from the north this time, with chimney smoking, in a view which shows the buildings and chimney of Steed's Brewery vying with the church tower as landmarks on the skyline.

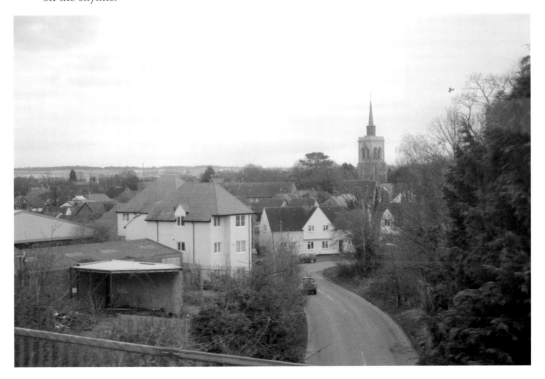

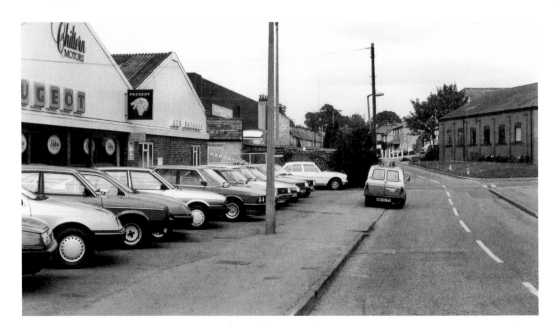

Deadmans Lane

In less than forty years, this road had three names. In 1880 it was known as Deadmans Lane, then by the start of the twentieth century it was known as Bygrave Lane. By 1920, it was Icknield Way, which it remains to this day. The earlier photograph dates from 1983; LTG Baldock continues today in Letchworth, while the site here is used as a car wash. Residential developments on the south side of Icknield Way since the 1980s have been Sanvignes Court (middle distance) and Eagle Court (on the site of the Stag, far right). *R. F. Page*

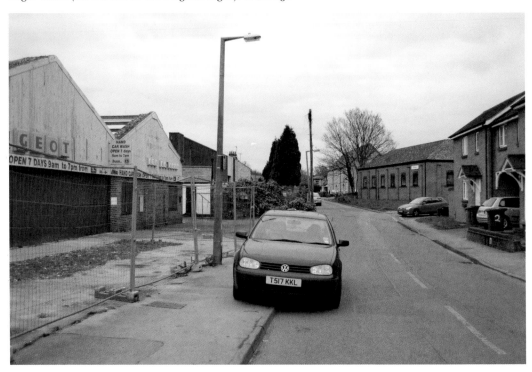

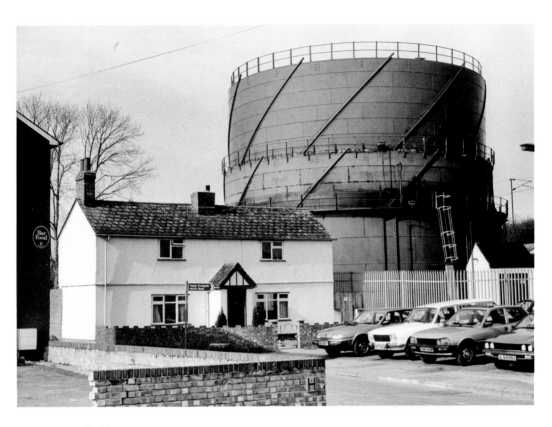

Gasworks House
Number 76 Icknield Way was part of the estate of the Baldock Gas Light & Coke Company. It was demolished in 1987 and today the eight flats of Icknield Corner occupy the site. *R. F. Page*

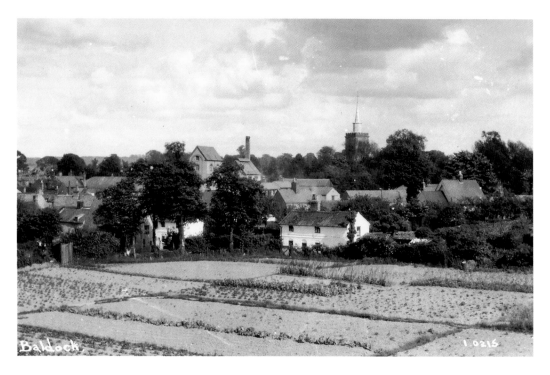

Norton End from the Railway

A view from the railway across the allotments, towards the section of the Icknield Way now obliterated by the sycamores. Apart from the church tower, the only building still standing identifiable in the earlier view is the Orange Tree pub (to the right of the church tower with a central chimney stack).

Norton Road
Baldock Bypass, opened in 1967, changed the view towards the town somewhat. Also, by straightening the bend in the road at this point, it has done little to keep speeds down! Baldock obtained its second bypass in 2006, which runs to the east of the town, partly in a tunnel. *Baldock Library*

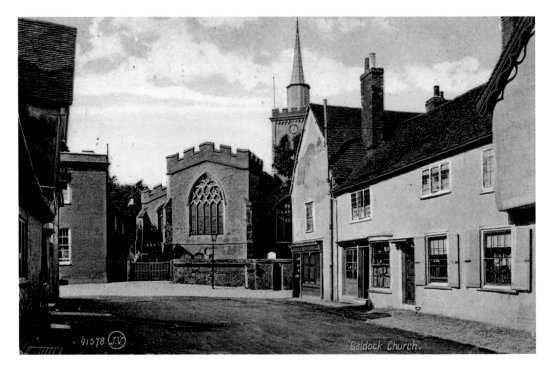

The Church from Sun Street

The chancel of the parish church of St Mary looks down Sun Street (and Whitehorse Street beyond). To the left of the churchyard, the brick frontage of No. 1 Church Street is visible. Behind this frontage is a timber-framed house, which is now incorporated into the George Hotel. The buildings to the left of the camera were formerly known as Middle Row and are typical examples of infill added to broad medieval streets.

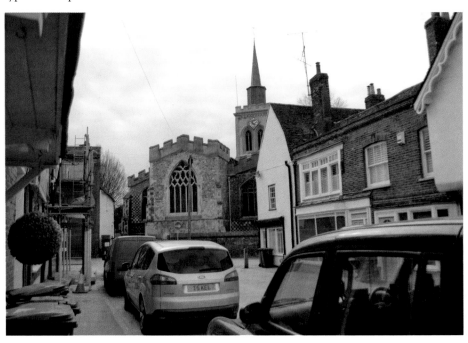

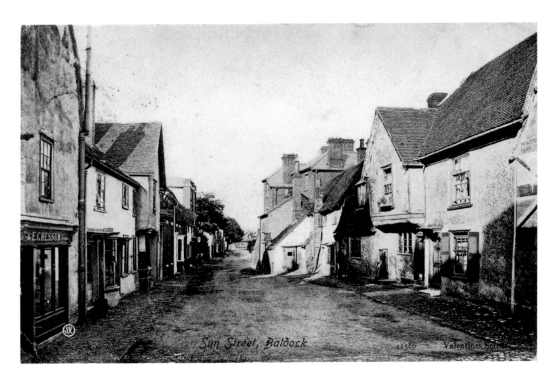

Sun Street

Once it had been created out of Whitehorse Street by the erection of the buildings seen on the right, Sun Street took its name from the inn at its east end. This is now called the Victoria and was rebuilt in the 1920s by the Luton brewer J. W. Green.

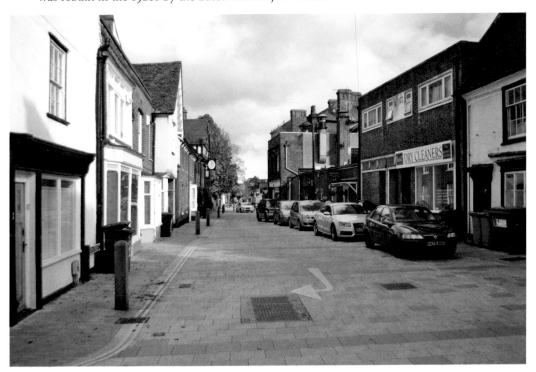

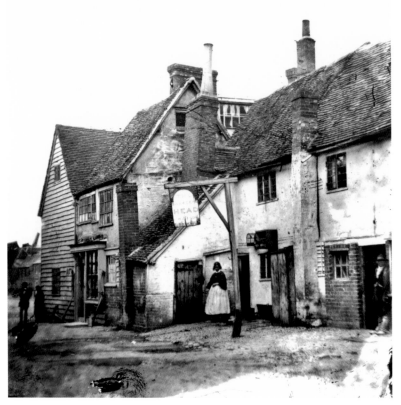

Saracens Head
The Sun/Victoria was not the only licensed house in Sun Street. The Saracens Head stood opposite until the early twentieth century. The licensee in the 1850s and 1860s, William Goodchild, was also Baldock's sexton.

The Iron Room

Opening in 1880 as a meeting place for the Plymouth Brethren, the 'Iron Room' in Orchard Road survived for more than 130 years. Properly known as the Gospel Hall, it was demolished in 2012 and replaced by a house called Chapel Corner.

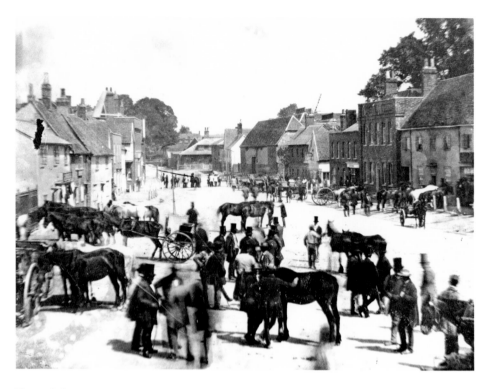

Horse Fair

Today, all market activity in Baldock is concentrated in the High Street, but the wide expanse of Whitehorse Street was also so used in the past. Dated around 1860, the earlier view shows the Horse Fair underway. Aside from the fair itself, the photograph is of interest for showing the yet to be rebuilt Checkers pub (No. 28 Whitehorse Street), as well as Nos 18 and 20 before they were refaced in Victorian brick. *Hitchin Museum*

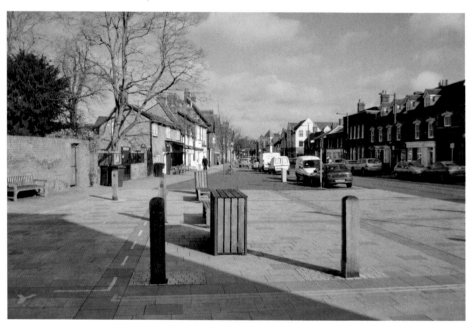

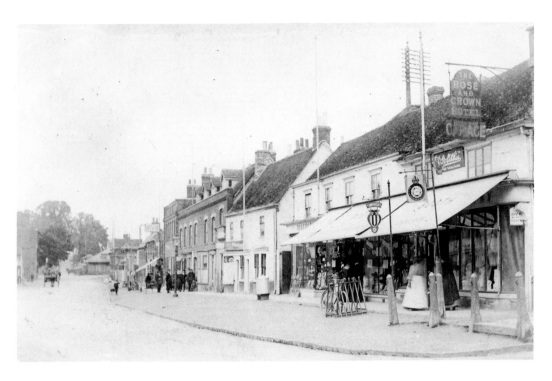

Whitehorse Street

The south side of Whitehorse Street around 1910. In the distance, the post office can be seen under construction, while nearer to the camera, the former Greyhound at No. 14 Whitehorse Street has become Bishop's ironmongers.

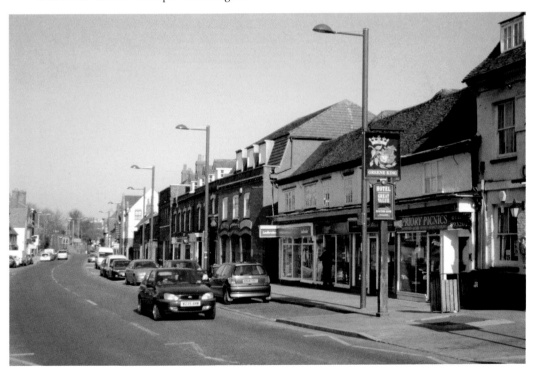

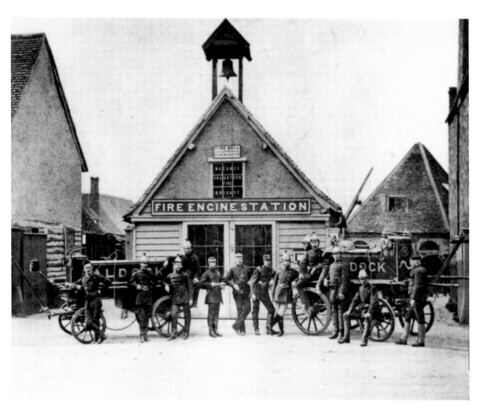

Fire Station, Whitehorse Street

Baldock's first fire station was in Whitehorse Street. After the fire station moved to the Town Hall in 1897, the old building would stand for another nine decades before demolition to make way for Alexander Court.

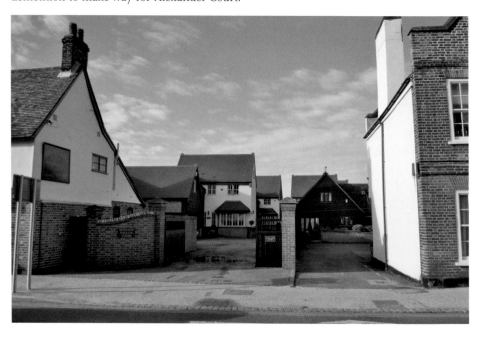

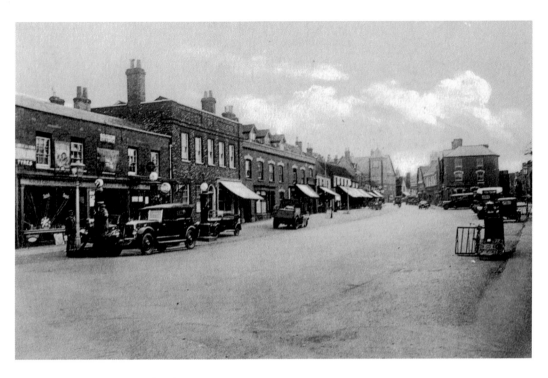

Butler & Munday, Whitehorse Street
Dating from 1896, Butler's Garage (later Butler & Munday) was a feature of Whitehorse Street for more than sixty years. Next door, at Oak House, Worbey's butcher's shop can be seen. In the 1960s it was one of two butcher's shops run by R. Chapman & Son.

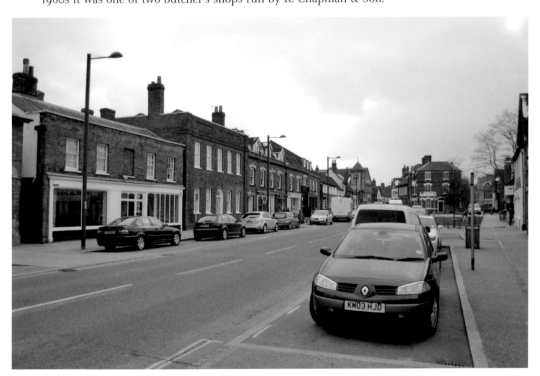

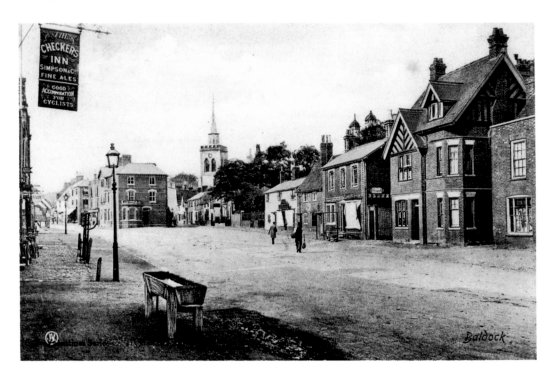

Whitehorse Street, Looking West

The view from outside the Checkers pub (today NVG and the Tagg Oram Partnership). The tyre and bicycles outside No. 24 Whitehorse Street are a reminder that Butler's Garage had its origins in the cycling boom of the late nineteenth century. The Victorian brick house at the end of Middle Row (between Whitehorse Street and Sun Street) was a solicitor's for many years until 2011.

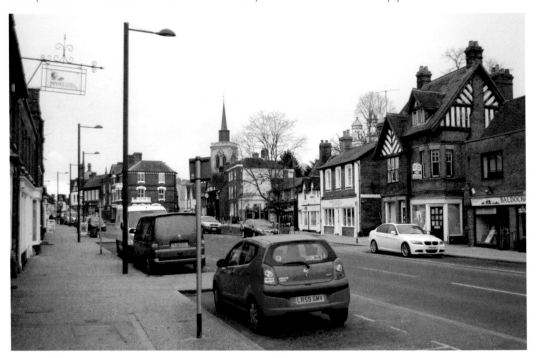

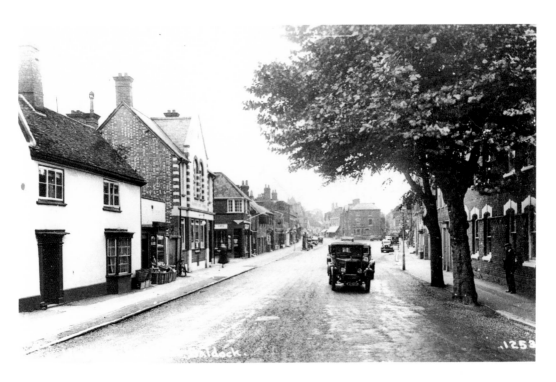

Whitehorse Street, East End

The earlier view shows Whitehorse Street just a few years after the Great North Road was given pride of place in the road classification programme as the A1. Numbers 37 and 39 Whitehorse Street, which were built on the site of the burnt-out White Horse Inn, were partly hidden by trees in the 1920s, but provide a commanding presence (as was no doubt always intended) in 2013.

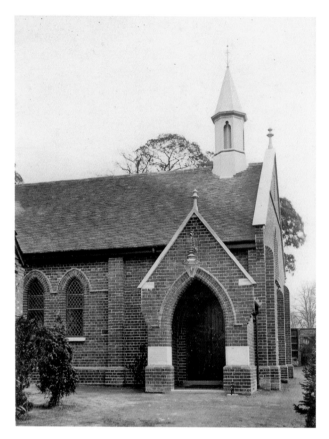

United Reformed Church
Baldock's Congregationalists first established a chapel in Pond Lane in 1826, building another chapel nearby in 1830. This was replaced by the Congregational church in Whitehorse Street, which held its first service at Easter, 1904. The earlier view shows the original entrance to the church, which underwent major refurbishment and improvement in 2011–12. *United Reformed Church*

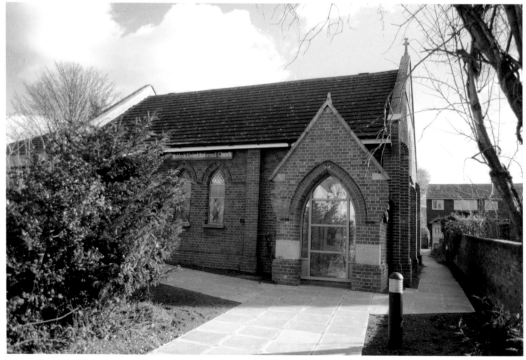

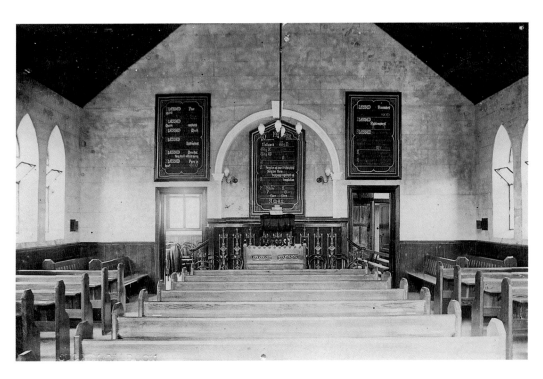

Inside the United Reformed Church
The refurbishment of 2011–12 included a 'turning round' of the church. The pulpit is now at the west end of the building rather than the east end, as seen in the earlier view. *United Reformed Church*

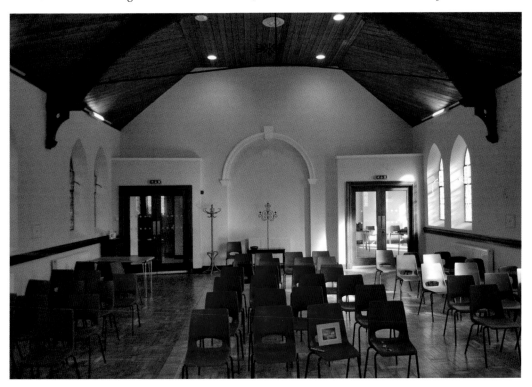

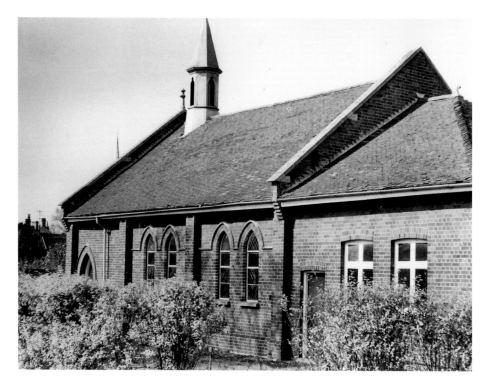

United Reformed Church from the South

Built on garden ground formerly associated with Grove House on the opposite side of Whitehorse Street, the United Reformed church was known colloquially as 'the church in the garden'. The contemporary view shows the church days before its reopening 2012. *United Reformed Church*

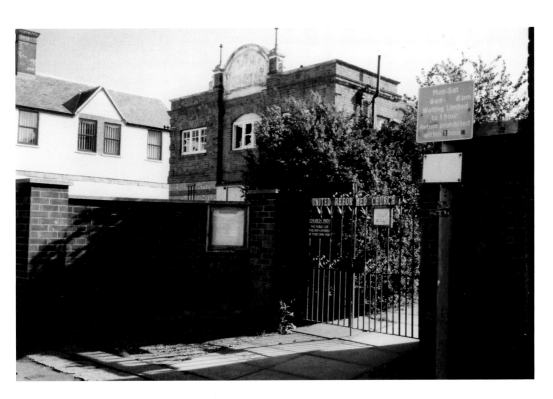

The Cinema

Baldock's first cinema opened at No. 34 Whitehorse Street in 1913 and lasted for a quarter of a century. It closed after a new cinema, the Astonia, was opened by the proprietor, Noel Aston Ayres, just before the Second World War and saw storage and industrial use until the 1990s when it was replaced by the Pearl Court flats. *Penny Oliver*

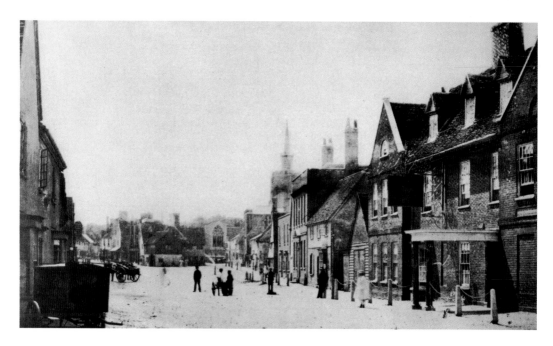

The White Horse

The earlier view shows the White Horse Inn around 1860, which gave Whitehorse Street its current name. The building was largely destroyed by fire in 1873, leaving just one section standing which is now No. 35 Whitehorse Street. Ironically, the small building next door would become Baldock's fire station (*see page 30*).

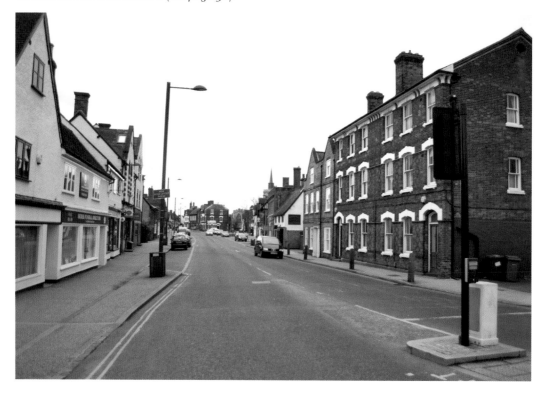

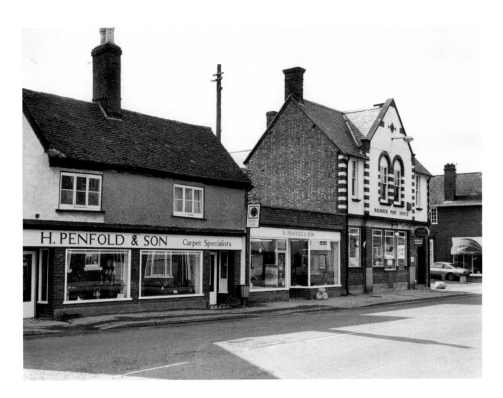

Penfold's Shop

The house that in the 1980s was Penfold's carpet shop, was in the late eighteenth century the home of brewer James Ind. The post office, completed in 1911, bears some similarity to that at Stevenage opened in 1909. Both buildings were financed by Stevenage entrepreneur John Inns and thus bear his initials on the gable. To the right of the post office in the earlier photograph, Baldock Cinema Tea Rooms, which opened in 1929, can be seen. *R. F. Page*

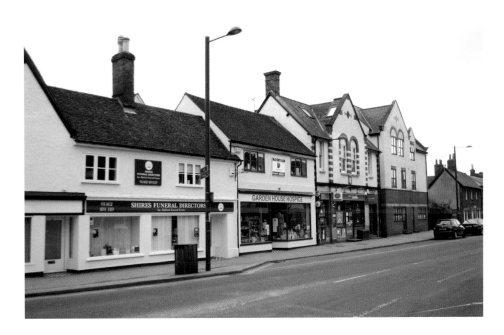

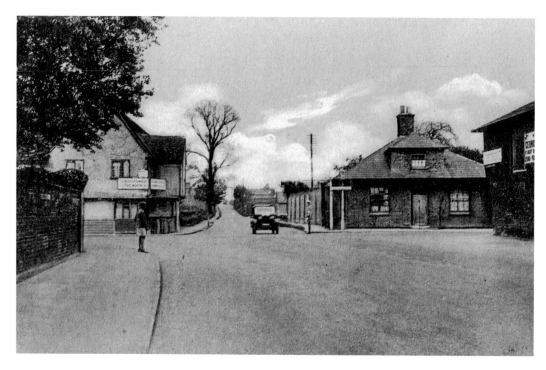

Cross Road

The A505 (formerly the A601) to Royston was the only main road exit from the town that did not require a sharp turn. Pryor's maltings is on the extreme right in the earlier view, bearing, like other buildings in the town, directions to the George & Dragon.

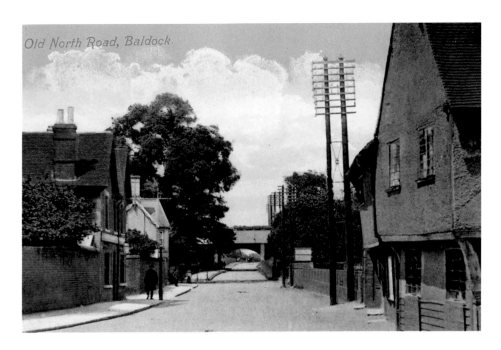

Station Road

The view north from the crossroads, shortly after the North Road became the A1. (The postcard caption is mistaken; the Old North Road passes through Royston 8 miles away.) The Old White Horse, which is believed to have been the tap for the pre-1873 White Horse, and the Engine are seen on the left.

Baldock, Station Road.

The Engine
Just by the entrance to Baldock railway station, the Engine pub is a fine Victorian building of
white brick; its finials and other embellishments match the optimism of the railway age.

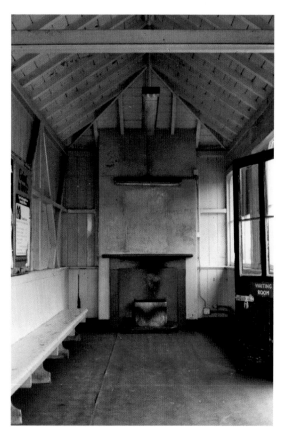

Down Waiting Room, Railway Station
The Hitchin & Royston Railway
opened to Baldock in 1850, just weeks
after the main line to the north, off
which it branches was opened. There
used to be a snug waiting room on
the Down (Royston) platform, seen in
the earlier photograph in 1980. This
was subsequently demolished during
'improvements' with today's open shelter.

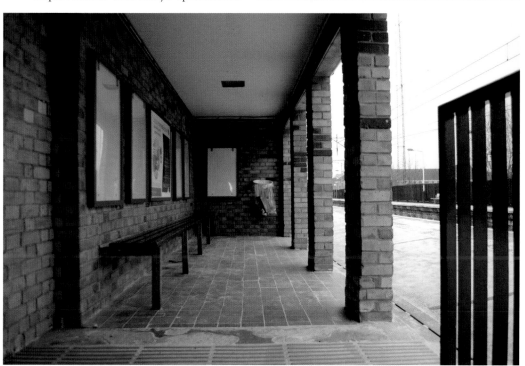

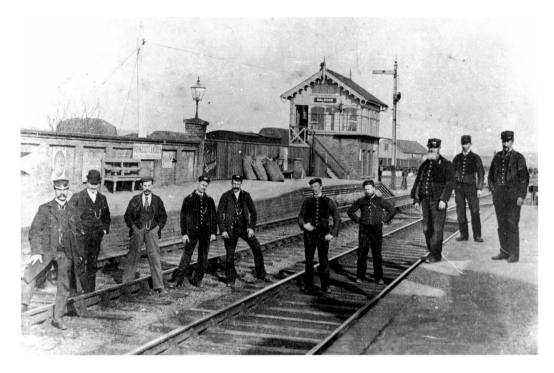

Down Platform, Railway Station
Staff pose for the camera in front of the signal box on the Down platform around a century ago. Before the realigning of Bygrave Road (*see page 46*), it crossed the railway at a level crossing just to the east of the station. *Hertfordshire Archives & Local Studies*

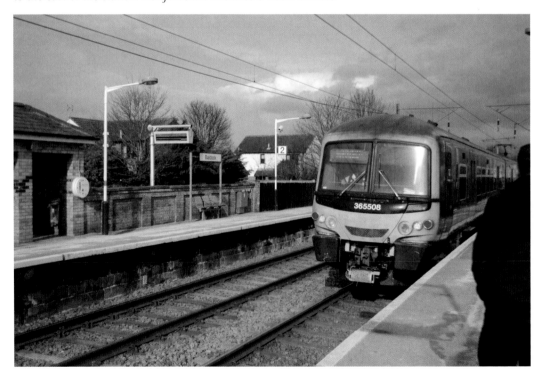

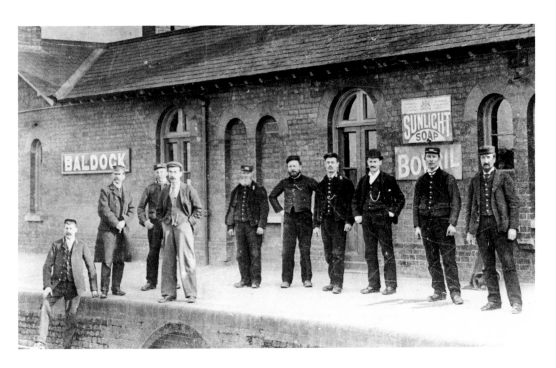

Up Platform, Railway Station

The same group swaps platforms for another shot. The distinctive arched doors of the station building have happily survived; unfortunately, today's view gives just as accurate a picture of the number of staff on duty at Baldock station as the earlier one! The ticket office is manned on weekdays from 6.40 a.m. until 1.30 p.m. *Hertfordshire Archives & Local Studies*

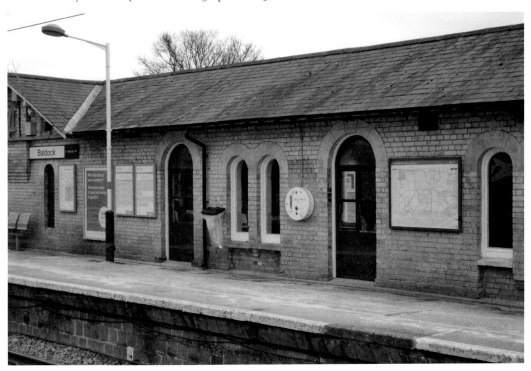

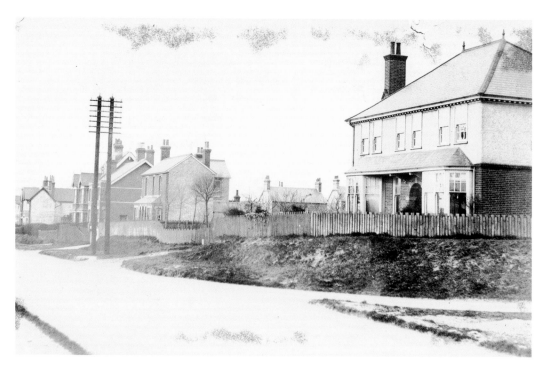

North Road at Bygrave Road Turning

At the end of the nineteenth century an estate of houses was built along the diverted Bygrave Road and newly laid out Salisbury Road. The houses fronting North Road have remained largely unchanged since the earlier view (a postcard) was sent in 1909. *Hertfordshire Archives & Local Studies*

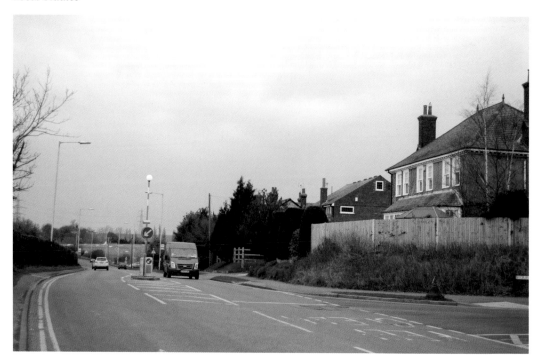

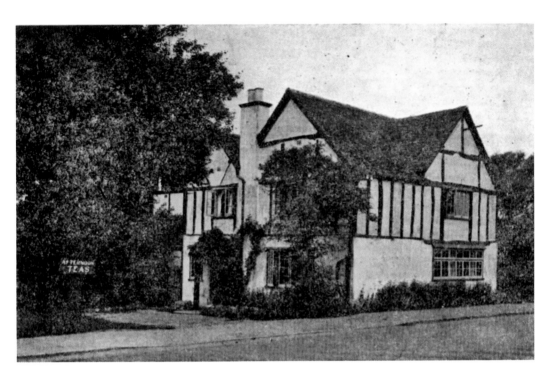

The Studio Café

The Studio was a popular stopping point on the North Road. It was one of three premises regularly advertising overnight accommodation in the town between the wars (the other two being the Rose & Crown and George & Dragon). Today it is called Templars Cross and still offers accommodation.

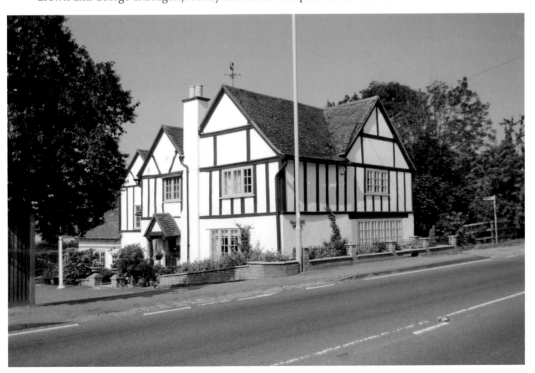

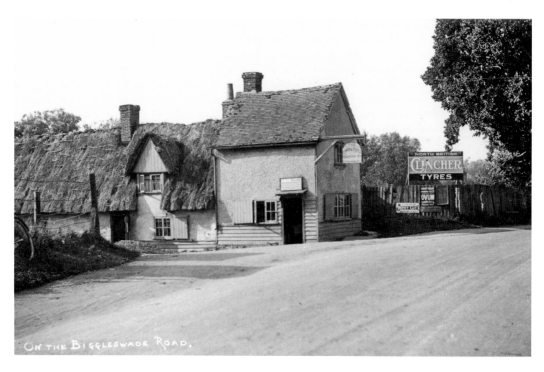

On the Biggleswade Road.

The Compasses

This picturesque old pub, which was in the parish of Bygrave, was closed at the end of the 1950s. Adjacent to the former watercress beds, the building dates from the seventeenth century or earlier.

Great North Road
The long, open stretch of the Great North Road. To the north is the turning for Radwell.

Raban Court from Station Road

The cottages that formed Nos 2–10 Station Road and Nos 1–3 Royston Road are today named Raban Court, after the Baldock building family. In early 1940s, one of these cottages was offered for a rent at 1/10d a week, a remarkably low figure even for the time. The houses were empty for thirteen years from the late 1940s, and there were fears that they would be demolished.

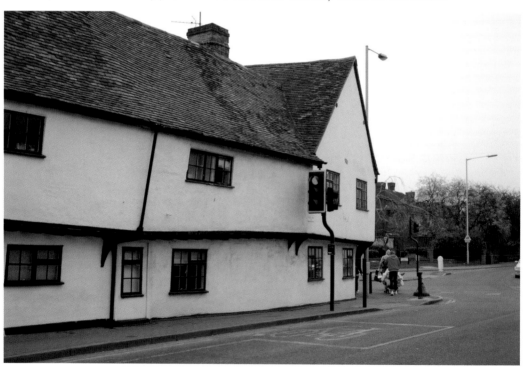

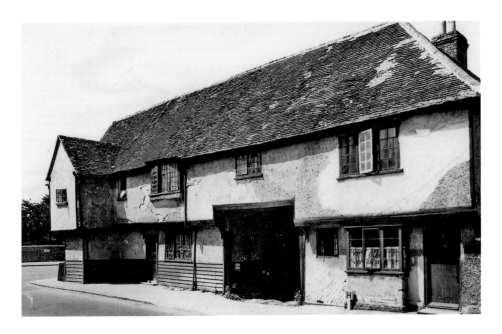

Raban Court, Royston Road

Raban Court is thought to have originated as the Talbot Inn, and to date from around 1540. Certainly the building occupies a prominent location, as the similar Bull Inn did at Hitchin. During the building works, completed in 1961, the cottages into which the complex had been divided were 'turned around', so that the entrances to all the houses and flats contained in the building are accessed from the courtyard rather than the street.

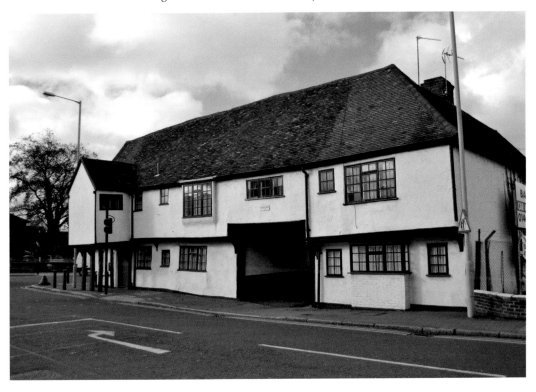

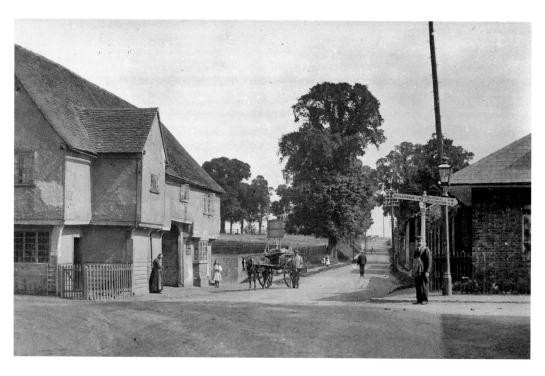

Royston Road
While a delivery postman poses for the camera, in the distance a cart can be seen parked outside the Toll Bar pub.

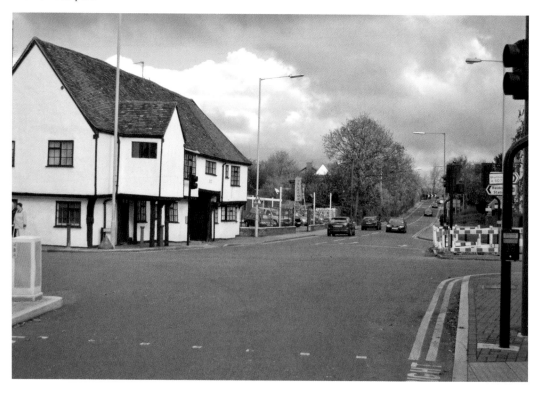

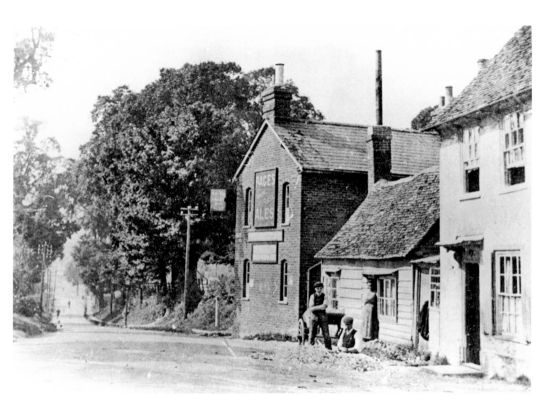

The Toll Bar

The Toll Bar beerhouse in Royston Road was actually in the parish of Clothall during the period when it was open for business. Today, the building is in Icknield Way East; before the rerouting of Bygrave Road to connect with North Road, this was where the road from Bygrave joined the Royston Road.

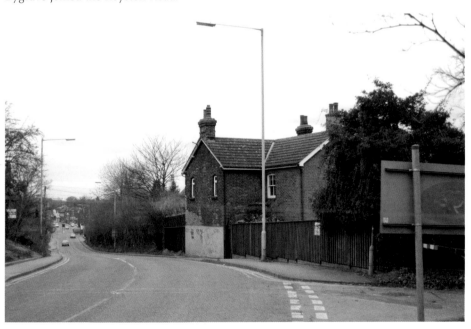

California, Looking North
The first group of cottages on the south side of Royston Road before the twentieth century was California. Now all the older buildings at California have gone; as with Norton End on the other side of Baldock, the area taken up by the cottages of old now looks incredibly small. *Baldock Library*

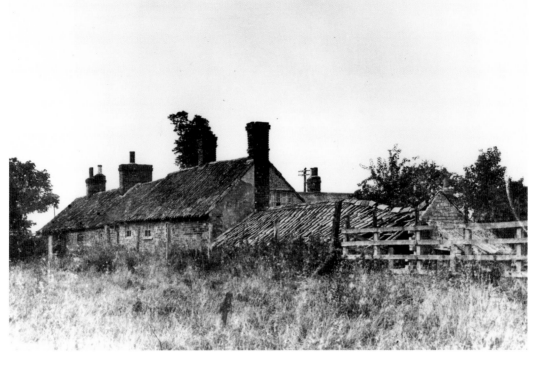

California from the South
The cottages of California, seen in the earlier view from the field where Grosvenor Road was built. The unrepaired outhouses did not bode well and sure enough the cottages are long gone. *Baldock Library*

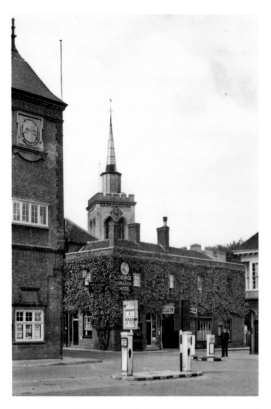

The Cross, from High Street
The centre of the town, where the Hitchin Street–Whitehorse Street and High Street–Church Street axes cross, is the location of the church, Town Hall and premier hotel. The hotel, the George (for many years the George & Dragon), at the corner of Hitchin and Church Streets, was leased out to Berni Inns before becoming a Greene King managed house in the early years of the twenty-first century.

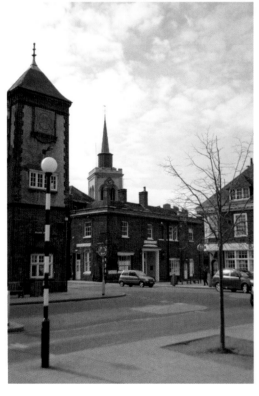

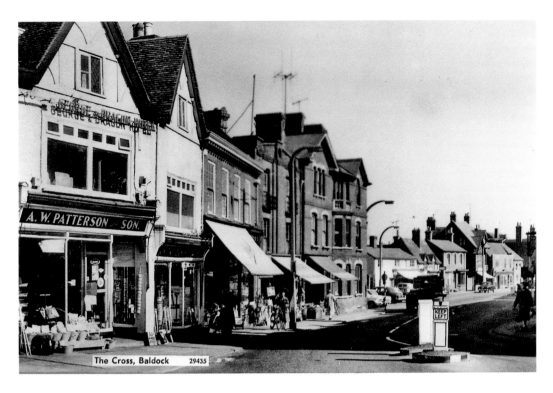

The Cross, Looking Along Whitehorse Street
Looking eastwards, the earlier view shows Patterson's ironmongers and cycle shop, which replaced the Plume of Feathers pub.

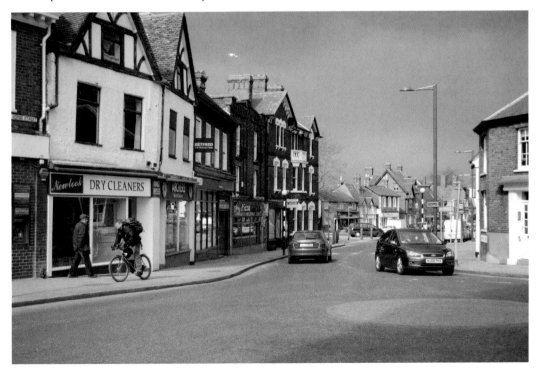

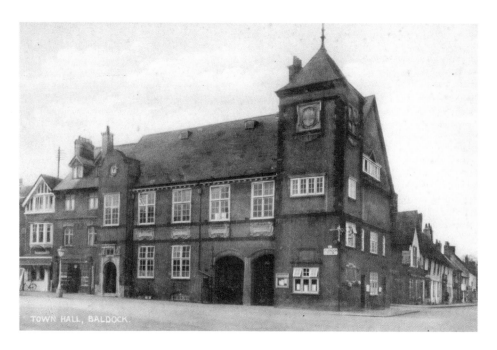

The Town Hall

Baldock Town Hall was opened in 1897, five years after a disastrous fire that laid waste to the site. The two arches marked the entrance of a new fire station, which moved here from Whitehorse Street (*see page 30*). With the replacement of Baldock Urban District Council by North Hertfordshire District Council in 1974, covering a swathe of Hertfordshire from Knebworth to Royston and the opening of a community centre on the site of Simpson's Brewery in 1979, the Town Hall has been underused in recent years. A committee of local residents has been set up to remedy this. The Town Hall is, however, the location of Baldock Museum, which can be entered from the Hitchin Street side.

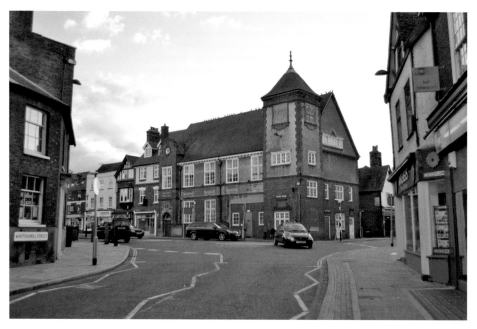

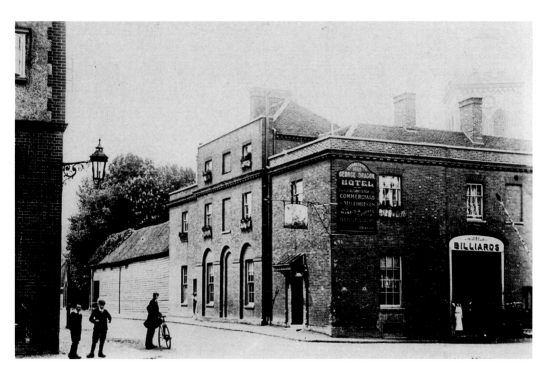

Hitchin Street, Showing the George & Dragon
The George reopened after a long period of closure on 10 April 2013. The lower view shows it the day before reopening when invited guests were given a preview.

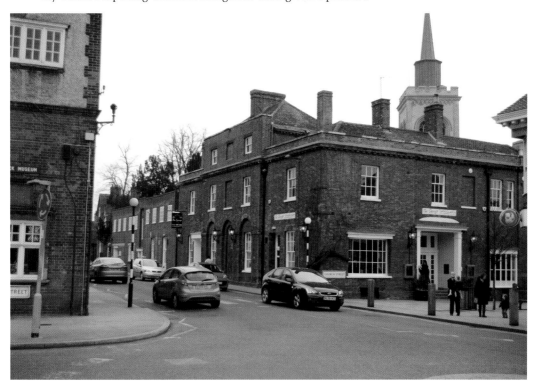

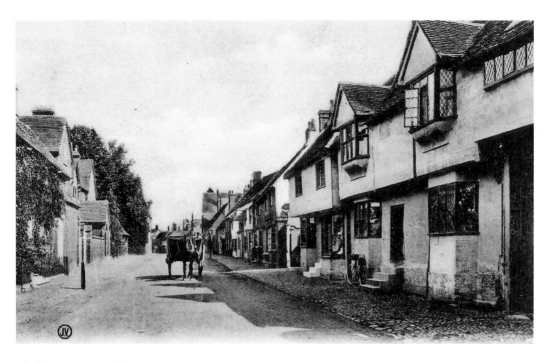

Hitchin Street, Looking East
Of all the main streets of Baldock, Hitchin Street has changed the least over the past hundred years. It retains a wealth of timber-framed buildings dating back to the sixteenth century.

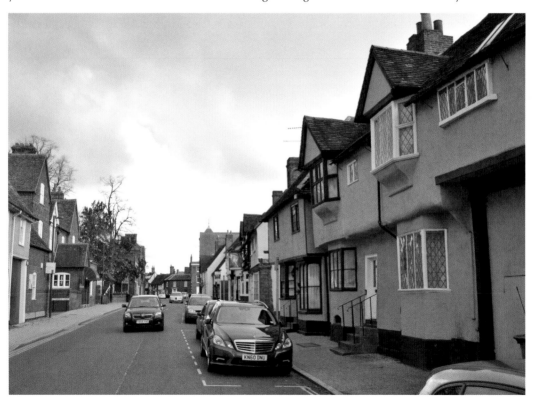

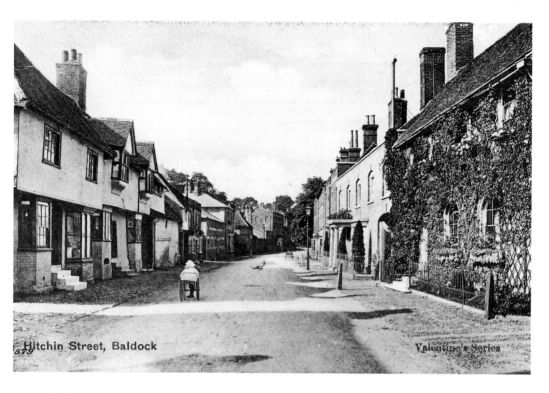

Hitchin Street, Looking West

With the large house known as The Wilderness at the far end of the street, Hitchin Street retains its timeless attractiveness intact.

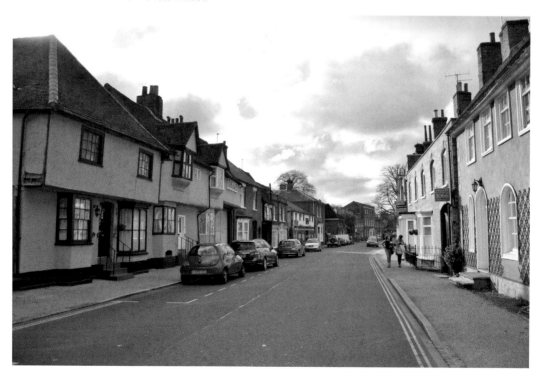

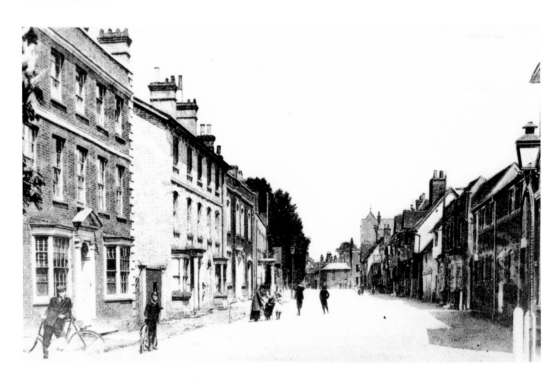

Hitchin Street from its West End
Cambridge House (left foreground) was a prominent private school in the nineteenth century. It is today divided into nine flats. *Stevenage Museum*

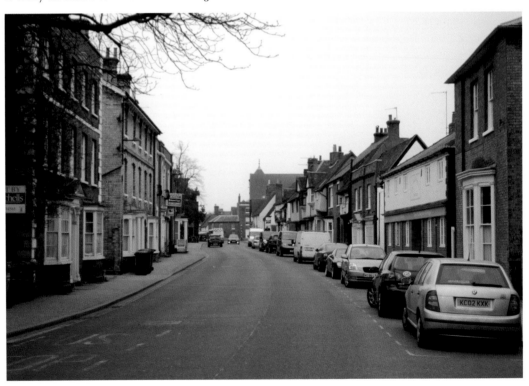

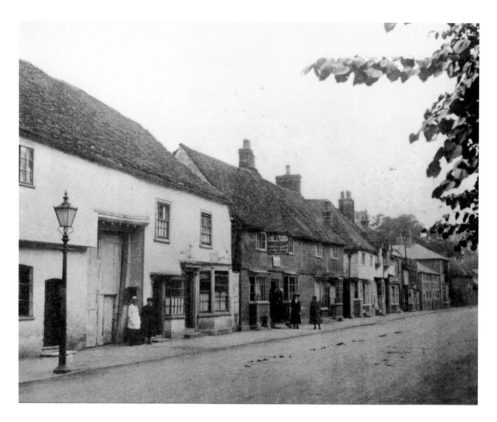

Hitchin Street Showing White Hart

The White Hart was rebuilt 1938 in a timber-framed style to match the rest of the street. One of the tie beams of the original building was incorporated into the new building and can be seen inside the bar.

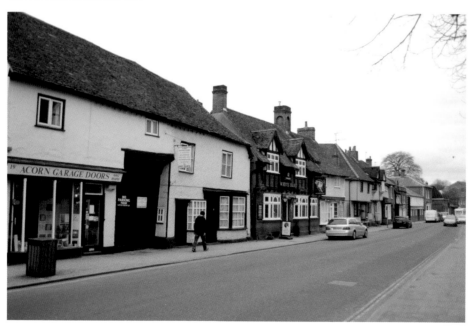

Weston Way Junction With Park Street

Although the curve has now been eased, the west end of Hitchin Street used to see a sharp swerve to meet this crossroads with Park Street seen to the left, Weston Way (then called Back Lane) seen straight ahead, and Hitchin Road (now Letchworth Road) seen to the right.

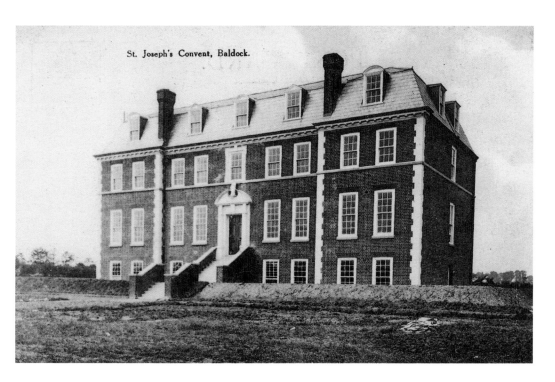

St. Joseph's Convent, Baldock.

St Joseph's Convent

Built in 1908 by the Sisters of St Mary & Joseph from France, the convent served as a hospital for elderly women for much of its life, before being taken over by Derek Prince Ministries in 1993 when it was renamed Kingsfield. Hadrian Way has been built on part of its grounds.

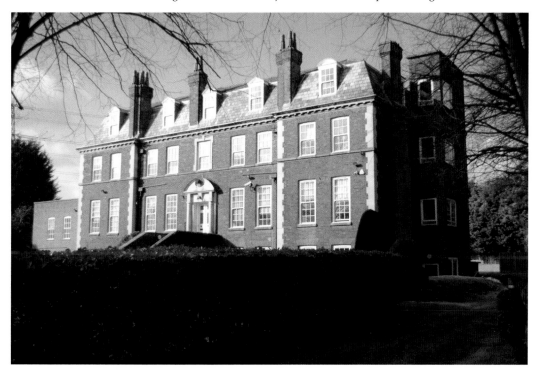

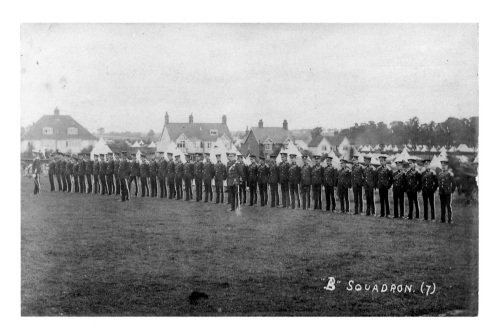

"B" SQUADRON. (7)

The 1912 Camp

Major military manoeuvres were held in 1912 as Europe moved closer towards war. A military camp was established on the fields of New Farm, where officers are seen drilling. The houses on the left of the photograph fell prey to the Baldock Bypass in the 1960s, but Burleigh House, which is now a care home, remains today.

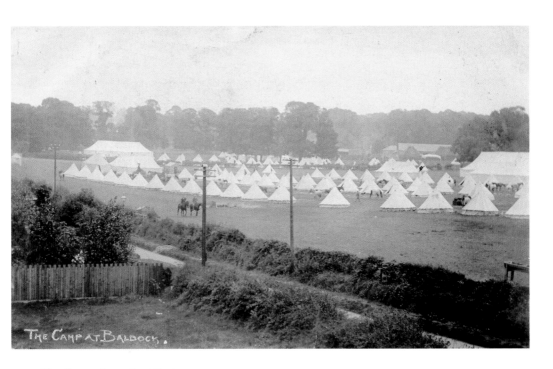

The Camp from the West

Seen from what is now the site of the A1(M) Baldock Bypass, the camp occupies the field now used by Knights Templar Sports Centre. The road in the foreground was then called Hitchin Road, but is now Letchworth Road. The original road is now just a service for the Letchworth Road houses. Through traffic uses a parallel carriageway the other side of the hedge.

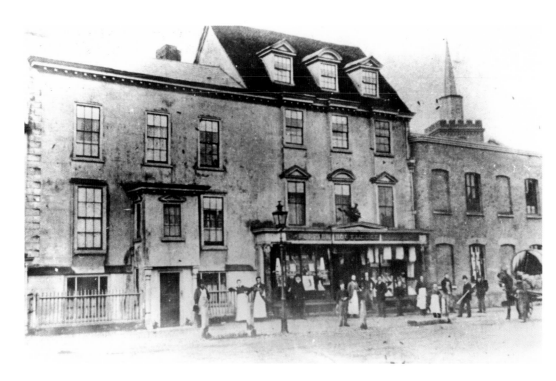

The High Street Fire

In 1892 the face of Baldock High Street was changed forever. A fire took hold very quickly at the premises of Buck & Solomon (seen here a few years earlier when owned by Mr Routledge). All three buildings in the earlier view were destroyed, luckily with no loss of life. Hitchin Fire Brigade came to assist the Baldock men, but within two hours there was little left of the buildings but a burnt-out shell. Buck & Solomon moved to the other side of the street after the fire and just over five years later, Baldock's Town Hall was opened on the site.

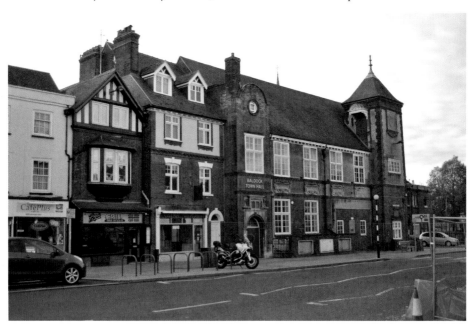

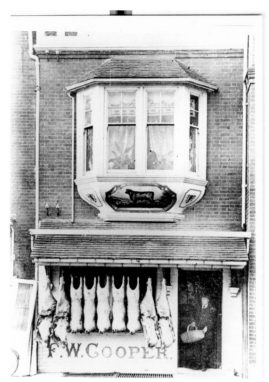

Cooper's Butcher's Shop
Cooper's the butcher's was at No. 4 High Street, next to the Town Hall. Only ready-cooked meat is sold here now!

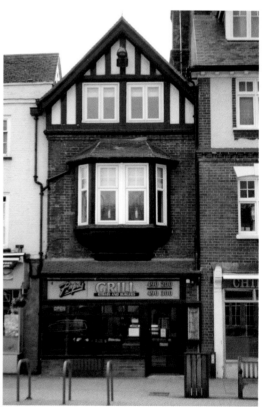

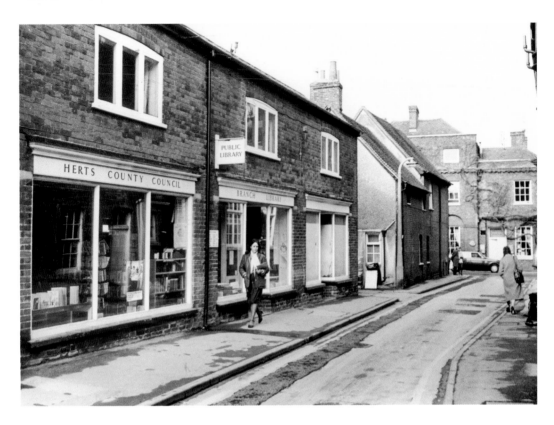

Bell Row

Baldock's public library was at No. 8 Bell Row until 1989, when it moved to the ground floor of the office block erected on the site of Simpson's Brewery. At six times the size of the old library, the new building repressed a great step forward. *R. F. Page*

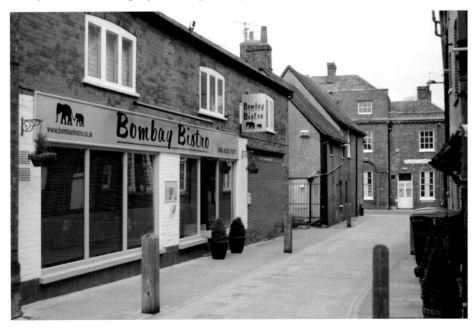

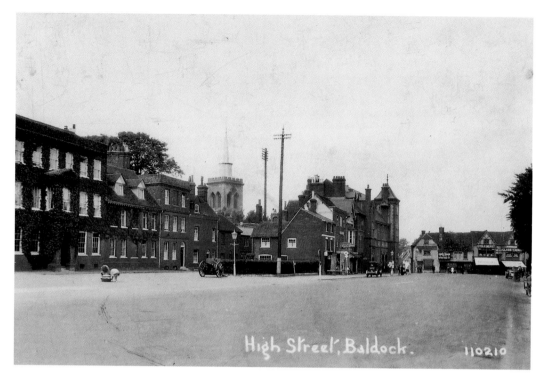

High Street Showing The Grange

The northern part of the High Street in the 1920s. At this time, a First World War field gun was on display at the south end of Bell Row outside The Grange. The Grange would become Baldock Urban District Council's offices in 1936.

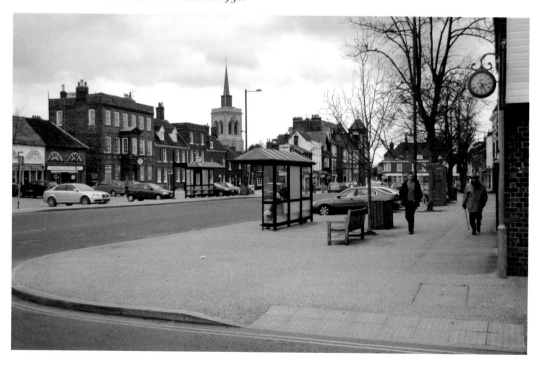

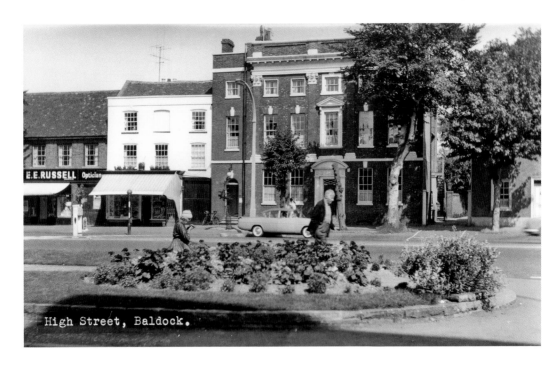

High Street, Baldock.

Russell's and Holford House

Russell's the chemist's was part of a very successful chain built up in the 50 years from 1911. Based in Letchworth, Russell's were manufacturing as well as retail chemists. Eventually, their shops were taken over by Lloyds. Holford House, a classic eighteenth-century Georgian building, is Grade II* listed.

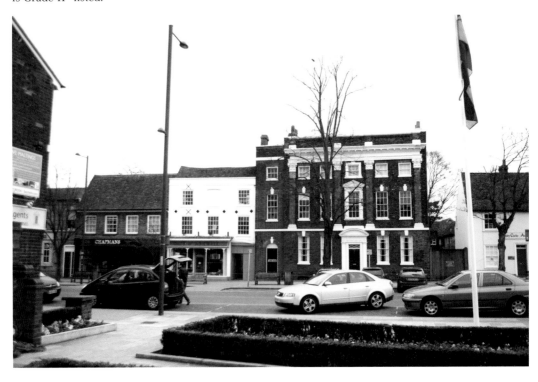

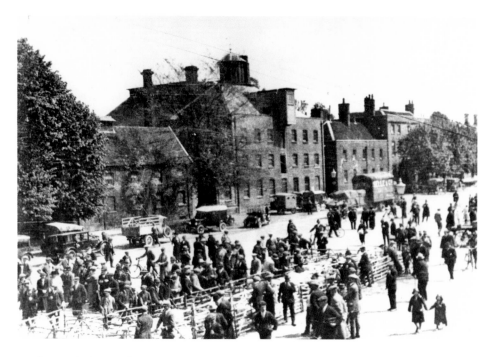

Market and Simpson's Brewery

In 1925, after a period of desuetude, Baldock's market was revived and occurred on Wednesdays. One of the early markets is pictured, with Simpson's Brewery behind. This was Baldock's largest brewery and continued in operation until 1965 as Greene King (Baldock) Ltd. In the end though, Greene King's acquisition of the Biggleswade Brewery of Wells & Winch in 1961, seven years after Simpson's, spelled the end for the High Street brewery, which was demolished in 1968. Twenty-one years later Baldock's current library was opened on its site.

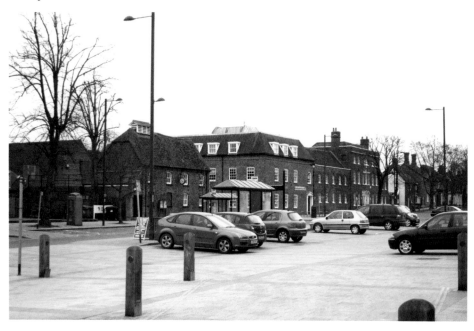

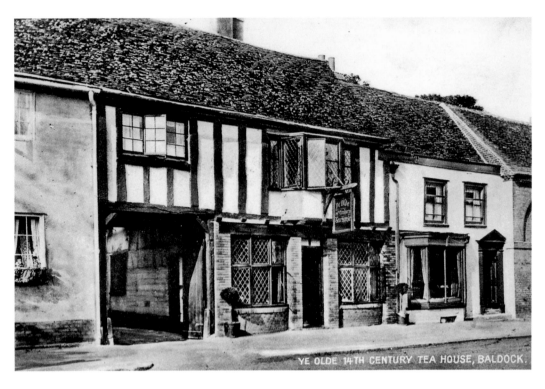

YE OLDE 14TH CENTURY TEA HOUSE, BALDOCK.

Ye Olde Fourteenth-Century Tea House
One of the most prominent and longest-lived of Baldock's cafés, the fourteenth-century tea house was not, of course, quite as old as it claimed. Housed in the building that was formerly the Albion pub, it is today Baldock Fish Bar.

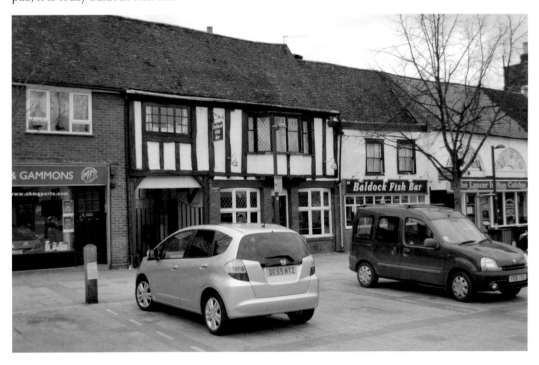

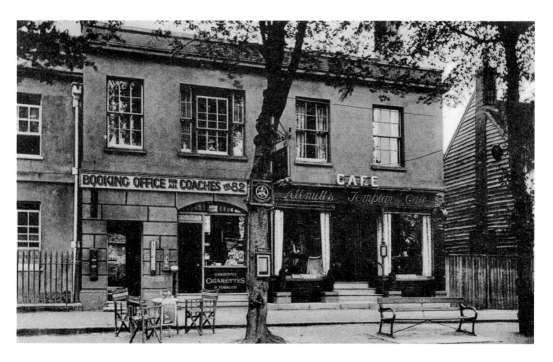

Allnutt's Templar Café

Allnutt's Templar Café was one of the main points of activity in Baldock High Street. Open at all hours, it was the booking point and stop for the long-distance coaches which mushroomed during the interwar years. Today, the building is the Zeus hotel and restaurant.

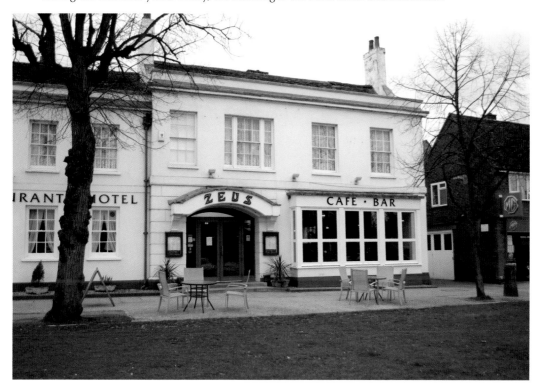

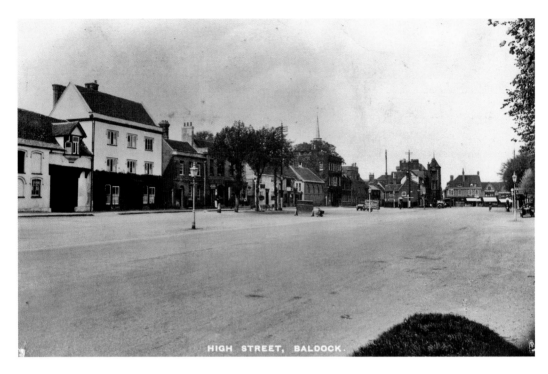

HIGH STREET, BALDOCK.

High Street Showing The Gates

Baldock is well-blessed with three-storey houses, mainly of classic Georgian style. Number 24 High Street, The Gates (nearest the camera in this 1930s view) is probably the most enigmatic of the large three-story houses. The southern wing with its gates (see opposite) was at this time still an ancillary building; in the postwar years it would be the Mayflower newsagent's and Baldock Travel Agency, before becoming Taste café bar.

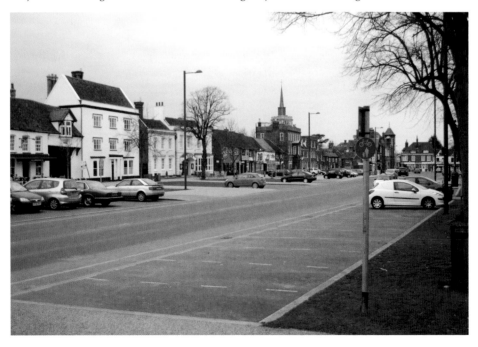

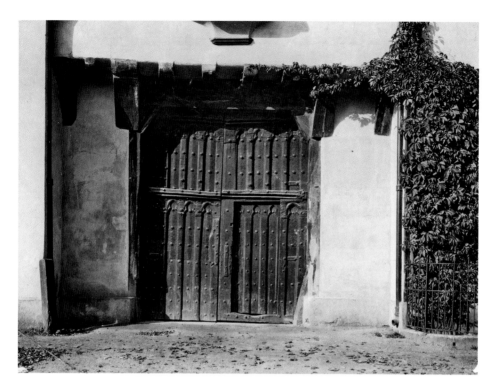

The Gates

Baldock is well provided with fine, venerable gates (such as at No. 3 Church Street and No. 20 Whitehorse Street), but by far the most outstanding are the gates on No. 24a High Street. These date from the fifteenth century and are believed to have come from the hospital of St Mary Magdalene, which stood just outside the then town boundary on Royston Road.

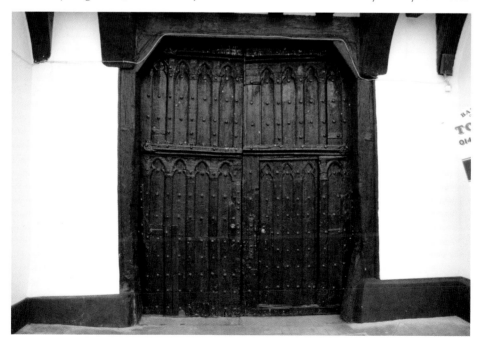

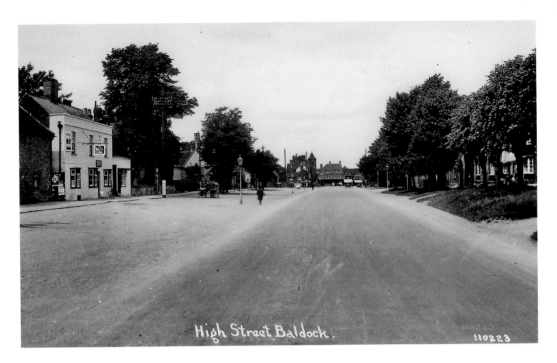

High Street Showing White Lion

A 1930s view looking north along the High Street. The White Lion is seen during its period as a Wells & Winch of Biggleswade pub, its brickwork having recently been painted over and its eaves-mounted carved lion removed. Recent changes to the High Street since the opening of the second (eastern) bypass have seen considerable areas put to grass.

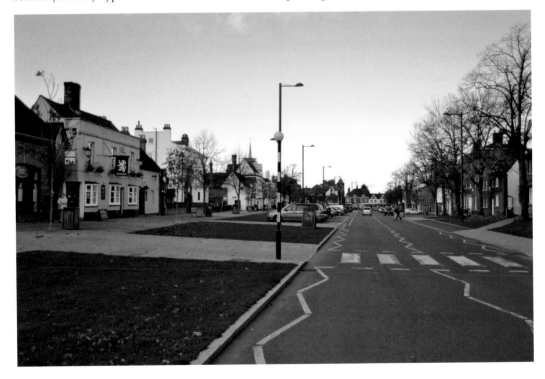

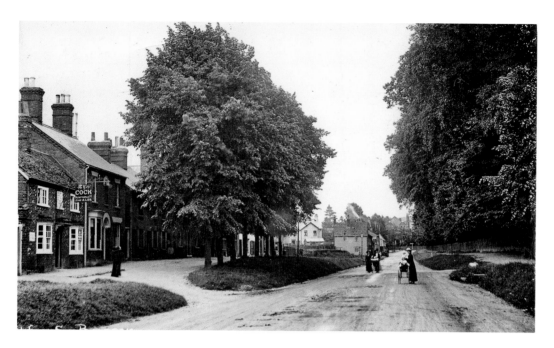

High Street Showing the Pretty Lamp

This view from the corner of Mansfield shows considerable change over the course of the twentieth century. While the Cock and the former police station next door have not changed much in appearance, the High Street further down has altered radically. The Pretty Lamp beerhouse had already closed by the time this photograph was taken, but its weatherboarded profile would remain for some years facing up the High Street, before the general rebuilding here at the same time as the road was widened. On the right hand side of the road, the trees of Elmwood Park overhang the footpath.

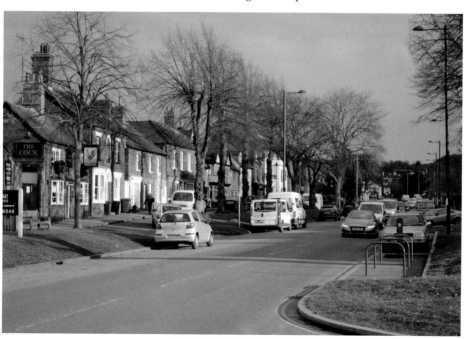

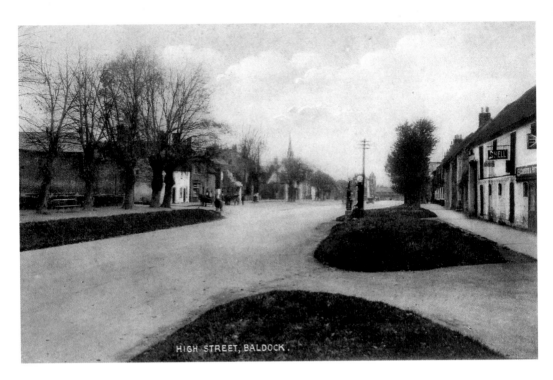

HIGH STREET, BALDOCK.

Carpenter & Potter's Garage

Looking north up the High Street from just outside the Cock. The building, which today is Finesse Interiors, was one of the garages that opened as the motor age unfolded. Some garages such as Butler & Munday, in Whitehorse Street, and Quenby Bros (still trading further up the High Street) lasted for many years. Others faded more quickly.

Pembroke End

This part of Baldock had long been known as Pembroke End, recalling Gilbert de Clare, the Earl of Pembroke, whose donation to the Knights Templar of the land to form the parish of Baldock, was responsible for the creation of the modern town. Number 65 High Street was the home of Baldock's Medical Officer Dr Suggitt, before being the location of Firth Construction in the 1960s. In the 1980s McCarthy & Stone put forward proposals to build retirement flats on the site and Elmwood Court was built. *R. F. Page*

Catholic Church of Holy Trinity & St Augustine

Baldock's first Roman Catholic church, dedicated to Holy Trinity and St Augustine of Canterbury, opened for worship in 1913. Beginning as a single-storey building, which later became the Presbytery, the church itself was never finished. It closed in 1977, as a new church at South Lodge, next to the site of the old Crown & Anchor pub, had been built. The church here has been replaced by two new houses and the Presbytery has been sold.
R. F. Page

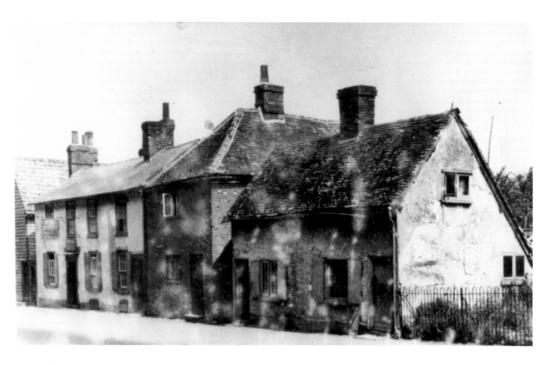

The Boot

Although of rather poor quality, the earlier view is of interest as it shows the Boot and adjacent houses prior to the 1920s rebuilding. With the widening of the road in the years immediately after the road received the 'A1' classification, it was an ideal time for Simpson's to rebuild the pub on early 'roadhouse' lines. *Baldock Library*

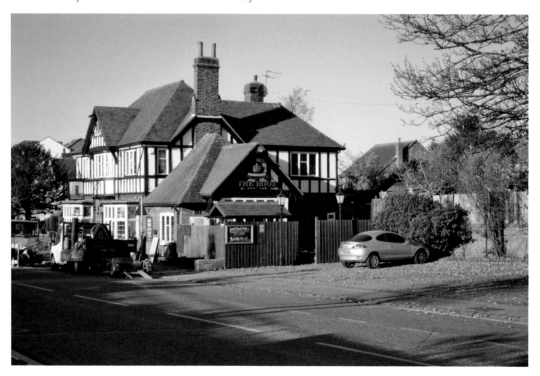

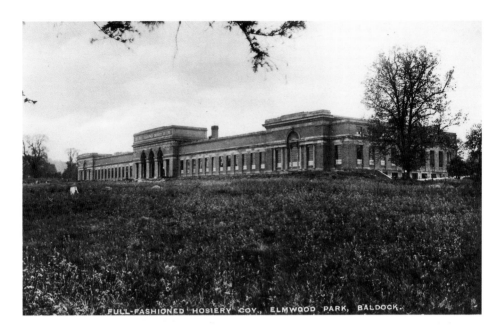

FULL-FASHIONED HOSIERY COY., ELMWOOD PARK, BALDOCK.

Full-Fashioned Hosiery Co.

In 1916 the large mansion on the south side of the High Street, variously known as Elmwood Park and The Elms, burnt down, leading to major changes for the town as a whole. In the 1920s, a photographic materials company built a factory with an enormous frontage in the park, but ran into financial difficulties before completing the building. It was taken over by the Full Fashioned Hosiery Company (known locally as FULFA), which within a few years was operating the largest hosiery factory in the world on this site. From 1936, the company was known as Kayser Bondor. Eventually, the hosiery market changed and the factory closed. For the second time in sixty years, the landmark frontage looked in endangered, but a Tesco superstore was built on the site, opening in 1988.

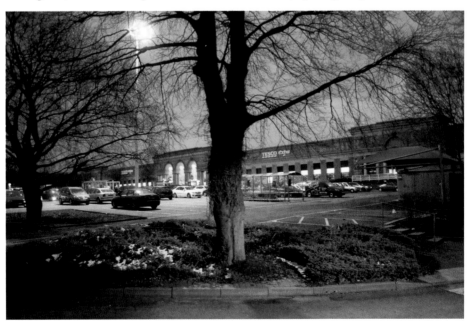

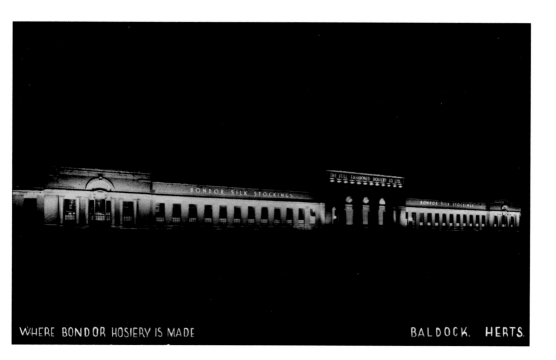

WHERE BONDOR HOSIERY IS MADE BALDOCK. HERTS.

FULFA by Night

The impact of the FULFA building on Baldock was marked and manifold. Postcards of it illuminated at night were good sellers and it has to be admitted that if Elmwood Park had not burned down in 1916, it is unlikely that the Rolling Stones would have played in Baldock (which they did at the Kayser Bondor Ballroom in 1963).

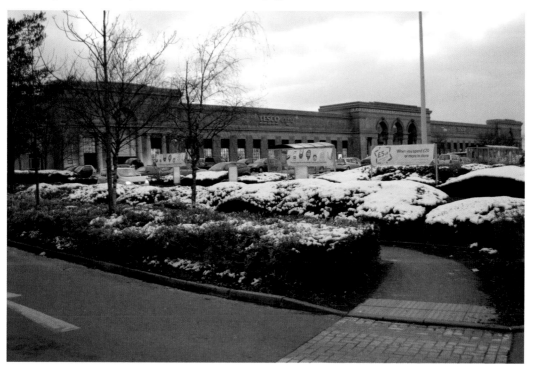

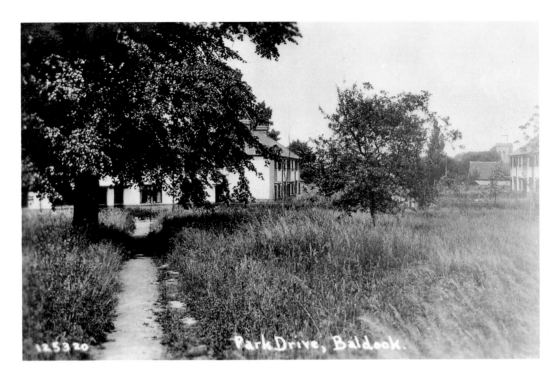

Park Drive

An early view of the housing provided by the Full Fashioned Hosiery Co. for its staff. The factory was largely responsible for the dramatic increase in Baldock's population from 2,518 in 1921 to 5,969 in 1951. After the Second World War, these houses passed to the ownership of Baldock Urban District Council.

New Road (Mansfield Road)

New Road was a leafy lane as seen here for more than forty years, running alongside Elmwood Park. When the Full Fashioned Hosiery Co. built its factory in the park in the 1920s, it built housing along the road, which was renamed Mansfield Road, reflecting where many of the FULFA employees came from.

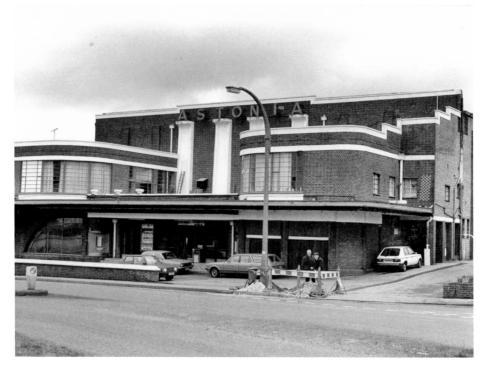

Astonia Cinema

Baldock's second cinema opened just before the Second World War at the south end of the High Street. Built by Noel Aston Ayres, it was the second Astonia, the first having been opened in Stevenage four years earlier. It ceased to show films at the end of 1969 and, after nearly twenty years as a bingo hall, was demolished in 1988. The name lives on, however, with Astonia House being constructed immediately afterwards. *R. F. Page*

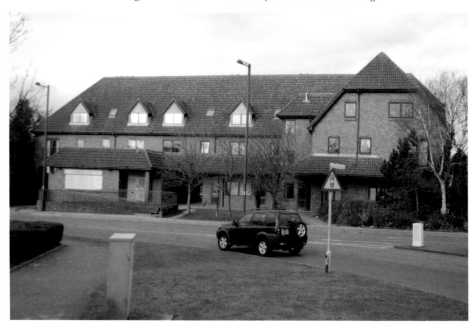

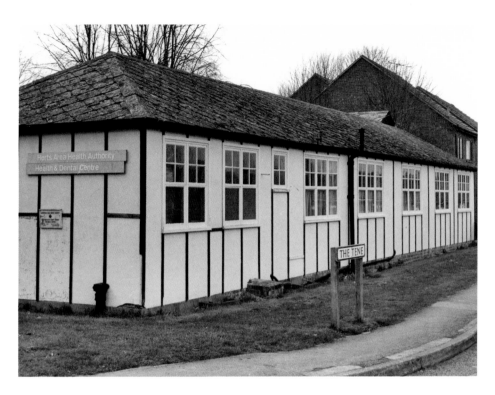

Pinnocks Lane Maternity & Child Welfare Centre

The Maternity & Child Welfare Centre stood at the corner of Pinnocks Lane and The Tene in the years before the health centre was opened at Astonia House. The Registrar of Births Marriages & Deaths would be in attendance here for an hour every Tuesday and Thursday. In its latter years the building was called the Health & Dental Centre. *R. F. Page*

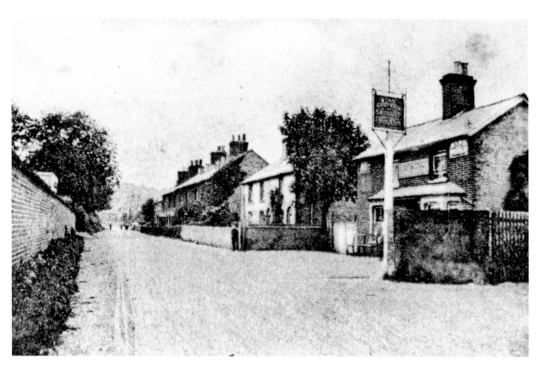

South Road
The Hen & Chickens has been rebuilt since the old postcard was made; recent residential developments have made this end of town quite densely populated.

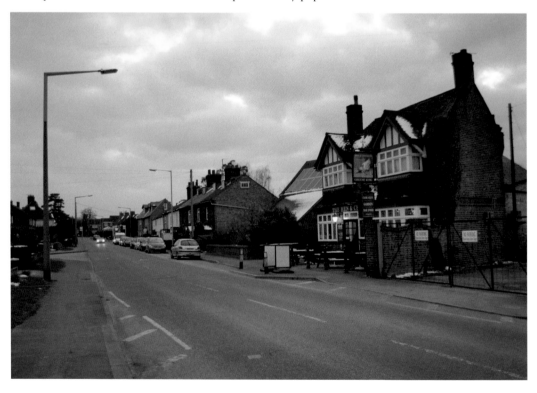

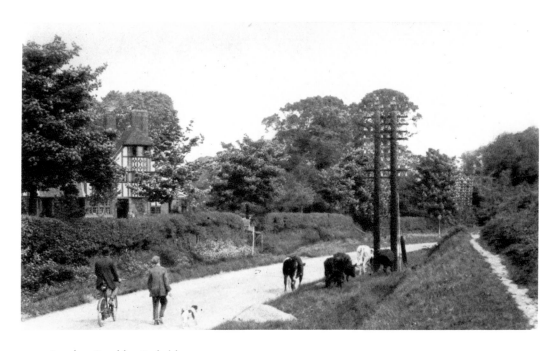

London Road by Parkside

The first house along London Road south of the Elmwood Park estate is the appropriately named Parkside. This Arts & Craft building to the design of Aylwin O. Cave is seen through the trees across London Road.

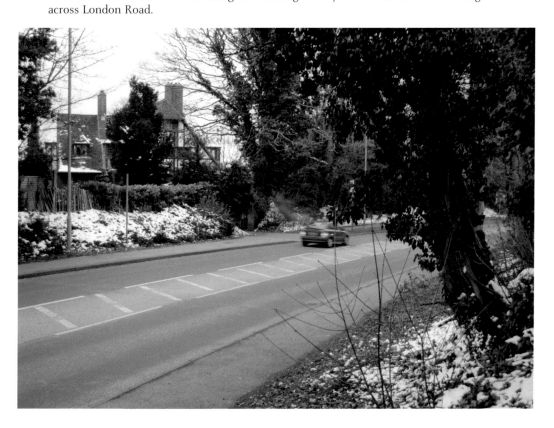

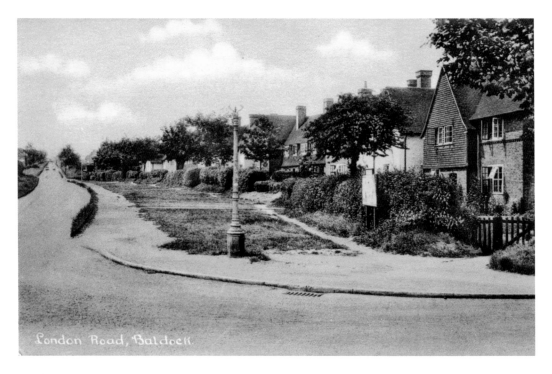

London Road by Templar Avenue

After the First World War, the London Road estate, filling the space between London Road, Weston Way and Crabtree Lane, was built, offering spacious, modern homes with gardens. Here the estate is seen looking south alongside London Road.

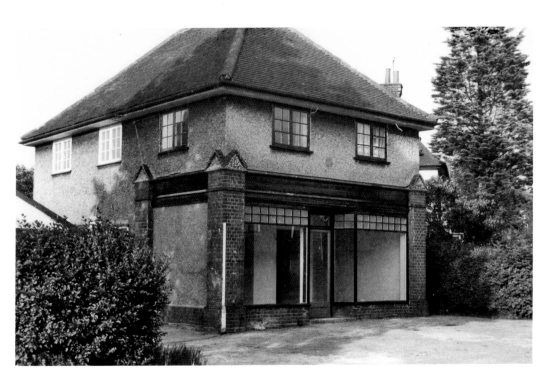

Martindale Court

The London Road estate had its own general store, The Stores, in Clare Crescent. By 1990, the proximity of the sub-post office in Weston Way and the general store in London Road had clearly had an effect and the building was standing empty. It has now been converted to flats and renamed Martindale Court. *Kenneth Johnson*

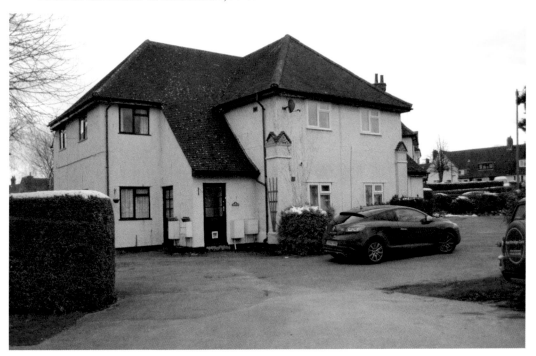

Weston Way
Looking north along Weston Way towards
the sub-post office by St Mary's Way.

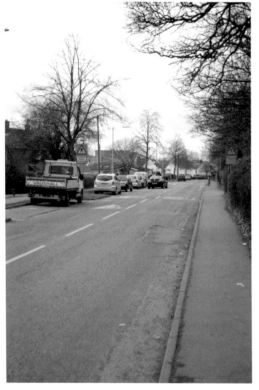

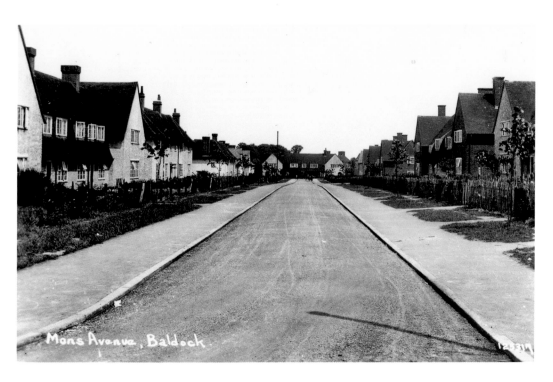

Mons Avenue

At the very opposite end of the town from Norton End, both literally and metaphorically, Mons Avenue is at the southern tip of the London Road estate. This postcard view looks northwards.

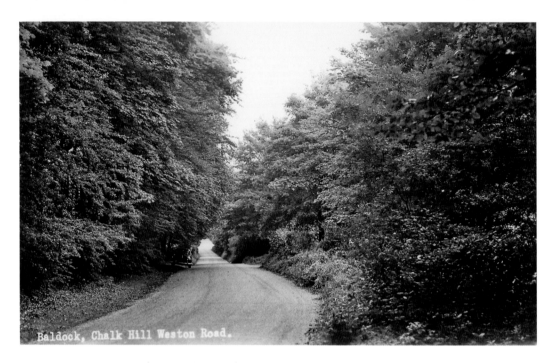

Baldock, Chalk Hill Weston Road.

Chalk Hill

The southern edge of Baldock is marked by the Weston Hills, a beauty spot and nature reserve to the east of the Great North Road. Rare species can be found here, including several varieties of wild orchid, and there are attractive woodland walks. The aptly-named Chalk Hill runs down from the Weston Hills to meet London Road by the George IV pub.